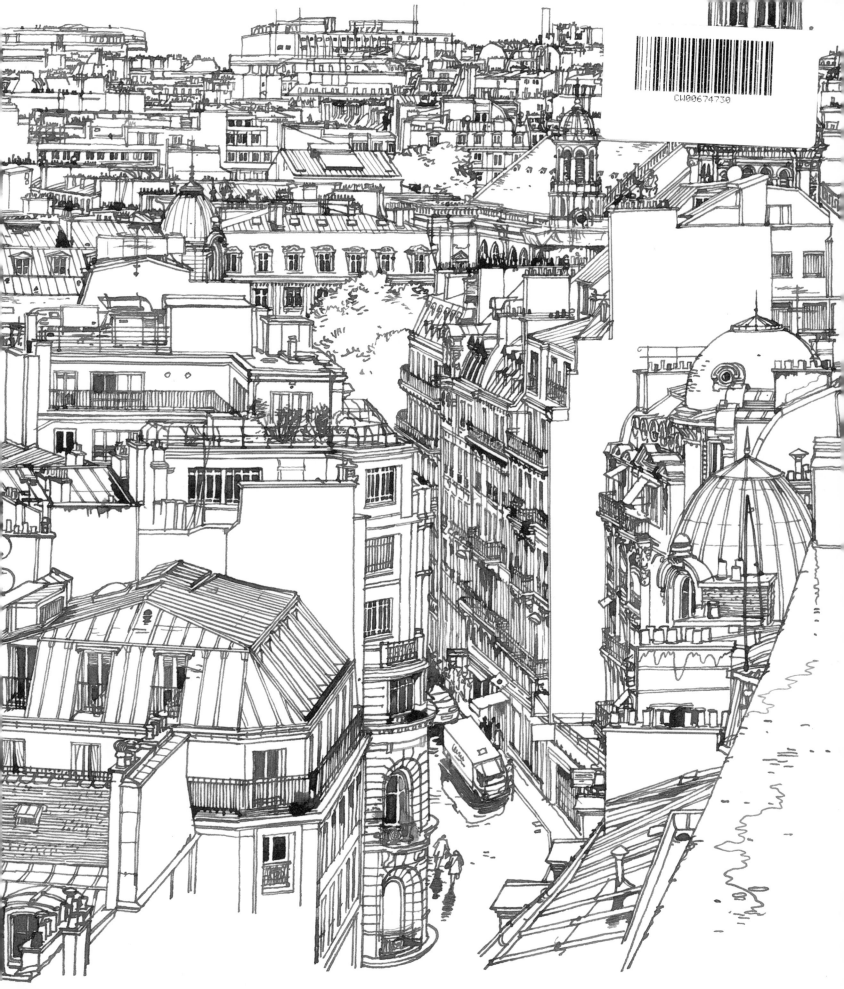

Rooftops of Paris

For their kind help, Fabrice Moireau wishes to thank Chantal de Lisle, Jean-Philippe and Dominique Lenclos, Michel Saunier, Musée du Quai Branly, Hermès, Ina Delcourt, Brebant Hotel and Nello Renault. Special thanks are also due to Hiroyuki Sasaki for giving permission to publish 15 of his watercolours.

ABOVE: 27 Boulevard Poissonnière, the former home of Frédéric Chopin.
OPPOSITE: workshops on Rue Ménilmontant, Belleville.
COVER: view of the rooftops of Paris from the Centre Georges-Pompidou.
BACK COVER: Fabrice Moireau sketching while seated on a Paris rooftop.
FRONT FLAP: the many colours of the roofs of Belleville.
BACK FLAP: Carl Norac standing on a roof in Paris.

Translation from French: Philippa Richmond and Timothy Auger
Managing editor: MCM

Illustrations © Fabrice Moireau

First published in French in 2010 as *Toits de Paris* by Les Éditions du Pacifique
5, rue Saint-Romain 75006 Paris

First published in English in 2010 by Editions Didier Millet Pte Ltd
121 Telok Ayer Street, Singapore 068590

The illustration on pages 40–41 is reproduced with the permission of Musée du Quai Branly.

The watercolours of Fabrice Moireau can be viewed at the Galerie des Éditions du Pacifique,
5, rue Saint-Romain, 75006 Paris. For more information, please visit www.leseditionsdupacifique.com.

Colour separation by Colourscan, Singapore
Printed by Star Standard, Singapore

ISBN: 978-981-4217-94-1

© 2010 Editions Didier Millet Pte Ltd

Rooftops of Paris

paintings **Fabrice Moireau** · text **Carl Norac**

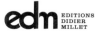
EDITIONS DIDIER MILLET

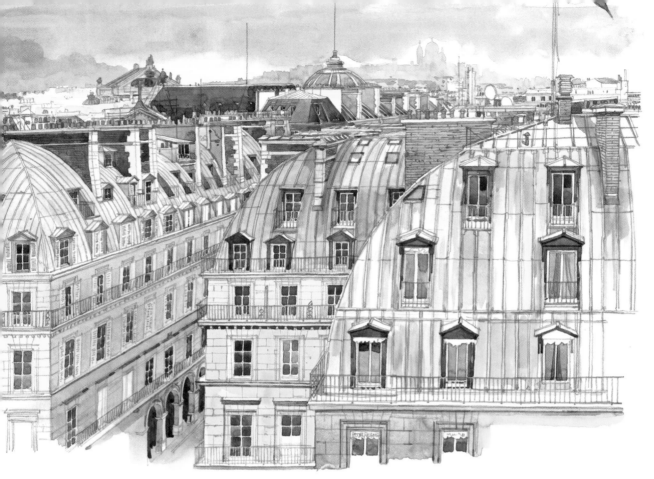

The Opéra – Garnier,
The Sacré-Coeur and the
Rue du Louvre seen from
the Musée des Arts Décoratifs,
Palais-Royal.

Paris on High

The rooftops of Paris have always been able to capture the imagination. They make up a landscape with which we feel familiar, and yet we barely know it. Books on Paris are legion. There are virtually none devoted to its rooftops, a fact which tends to support Jean Follain's elegant description of a city conceived from the roots upwards rather than from the roofs down: "The houses of Paris stand . . . magnificently wedded to the earth, to animal life at ground level, to the fauna of the deep. People live and die behind their grey windows."

This Paris, fixed, rooted, does exist, earthly and resplendent, but up on the rooftops there is a different world, a world of free forms where secrets reveal themselves to eyes patient enough to look. The idea behind this book was to bring to life the roofscape of Paris through the detail of watercolour, with paintings accompanied by text that goes beyond prosaic description to capture some of the poetic imaginings inspired by these rooftops, by what they tell us and what they hide.

The artist Fabrice Moireau undertook a close study of the city surveying it at roof level, with an entomologist's eye for detail. He went around slipping into apartment complexes, pretending to live in the buildings, and, taking opportunities as they presented themselves, climbed up to paint views while perched on high vantage points liable to give anyone vertigo. He wanted to include the city's lesser known nooks and crannies alongside the famous buildings and public places, with new ways of seeing and unusual angles. He is fascinated by this other side of Paris,

a levitated, almost unreal world and its architecture devoid of grandiose statements, an extravagant, almost unbelievable mass of shapes and forms and ingenious methods of giving protection from rain, wind and architectural monotony.

This book is an invitation to travel to a new and unfamiliar cityscape. For the artist, this entailed learning to read the roofs of Paris and decipher when they were built, the language of shapes, the game of identifying monuments from afar, set on a 360-degree horizon. And to experience the way in which colours merge and mingle, creating new and subtle intermediate shades, improvised and cheerfully harmonious.

As a watercolourist, Fabrice Moireau is also an explorer. The movement of his paintbrush is sometimes controlled, at other times more spontaneous. He picks up his distinctive case, and a little container of water, then takes to the roofs. Right up there, high above the city for longer periods even than a bird, his brush flying across the rough-textured paper, he seizes the moment with the spirit of a wanderer. Fabrice walks across roofs with a smile in his heart, delighted to have rung at the doors of strangers, to have persevered up meandering staircases, to have found the perfect window with its precious shaft of light. He sits for four or five hours at a time, eyes riveted but paintbrush and palette at work, fulfilling his mission to share with us what the eye sees, to present the images that are right in front of us.

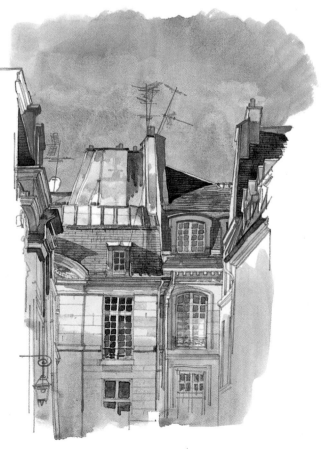

Rue du Temple, Marais.

For the poet too, the roofs are like manna from heaven, bringing him or her into a world full of fleeting silhouettes and the music of birdsong. The idea in this book was to describe places with, for once, the complete freedom to be inventive, to express in lyrical terms the sense of being at the very heart of things. The writer's words roam across the leaded rooftops, searching for the people who live beneath the crenellated horizon, observing for a moment a satellite dish perhaps, the odd grafitti, or a chimney that attracts the eye with a particularly expressive shape.

In the mind of the poet, there is an enduring dream: striding towards the sky in a single imaginative step, surrounded by something less tangible than air. Paul Claudel said that for the flight of a single butterfly, the entire sky is needed.

In this world where everything is measured and subjected to judgement, there is still a freer space into which we can all make our escape, be it with our eyes or, for those who dare, with our feet: the roofs, the roofs!

Rue Saint-Denis.
Marais.

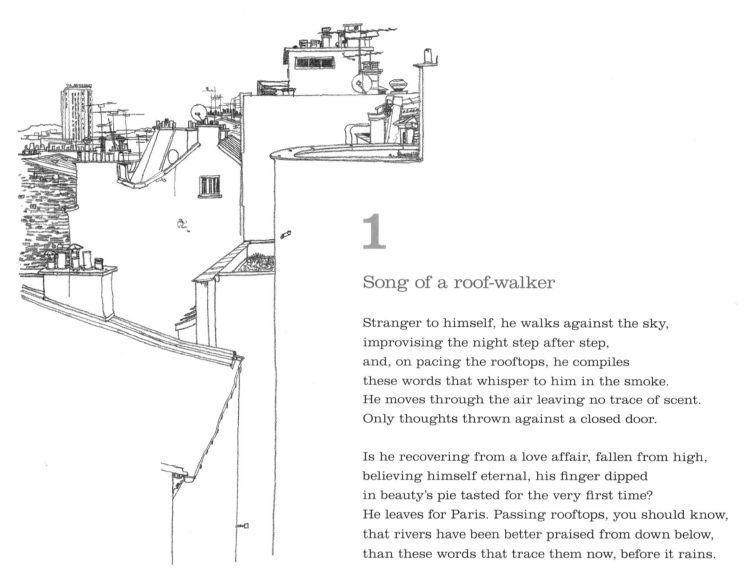

1

Song of a roof-walker

Stranger to himself, he walks against the sky,
improvising the night step after step,
and, on pacing the rooftops, he compiles
these words that whisper to him in the smoke.
He moves through the air leaving no trace of scent.
Only thoughts thrown against a closed door.

Is he recovering from a love affair, fallen from high,
believing himself eternal, his finger dipped
in beauty's pie tasted for the very first time?
He leaves for Paris. Passing rooftops, you should know,
that rivers have been better praised from down below,
than these words that trace them now, before it rains.

That's what they're worth at the depths of melancholy,
a few footsteps on footsteps like droplets of rain.
Paris does not exist unless in your mind's eye,
you let this finest of lights, a golden ray,
shine forth amid gentler lights in the streets
and on the rooftops paint a headier grey.

2

Skimming the rooftops

Only our eyes can follow the effects created by light. As the sun begins to follow its course, shadows waltz across the roofs. Everything our senses take in is a dance in which light and shade play off each other. As the light grows stronger the façades begin to emerge more clearly, overlapping, interlocking forms, planes of lead and, in the distance, delicate stairways of slate. At one moment the roofscape seems to be within reach, then it recedes to a distance. Lazily, indistinctly – that is how the mist speaks on the rooftops of Paris this morning. Dawn has arrived, unannounced. Another autumn begins. It always seems like the first one for lovers opening windows onto the Rue d'Arcole, but it's the last for the red and orange leaves about to invade these gardens. That is how the mist speaks in the city of light, recounting the seasons. Lazily, indistinctly.

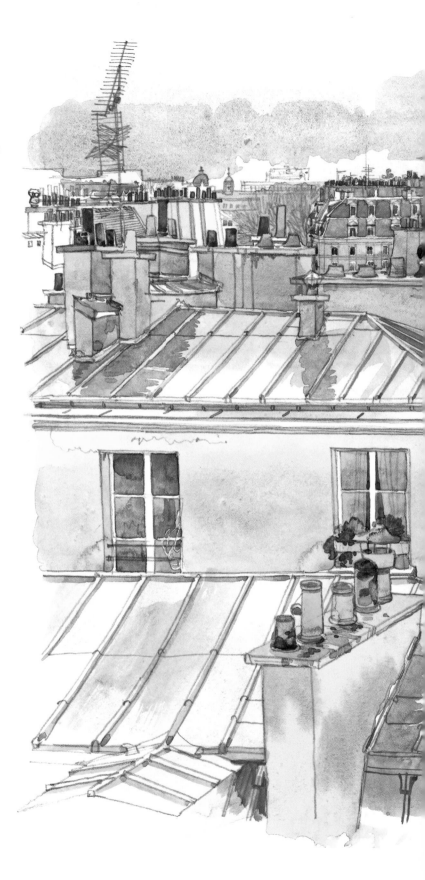

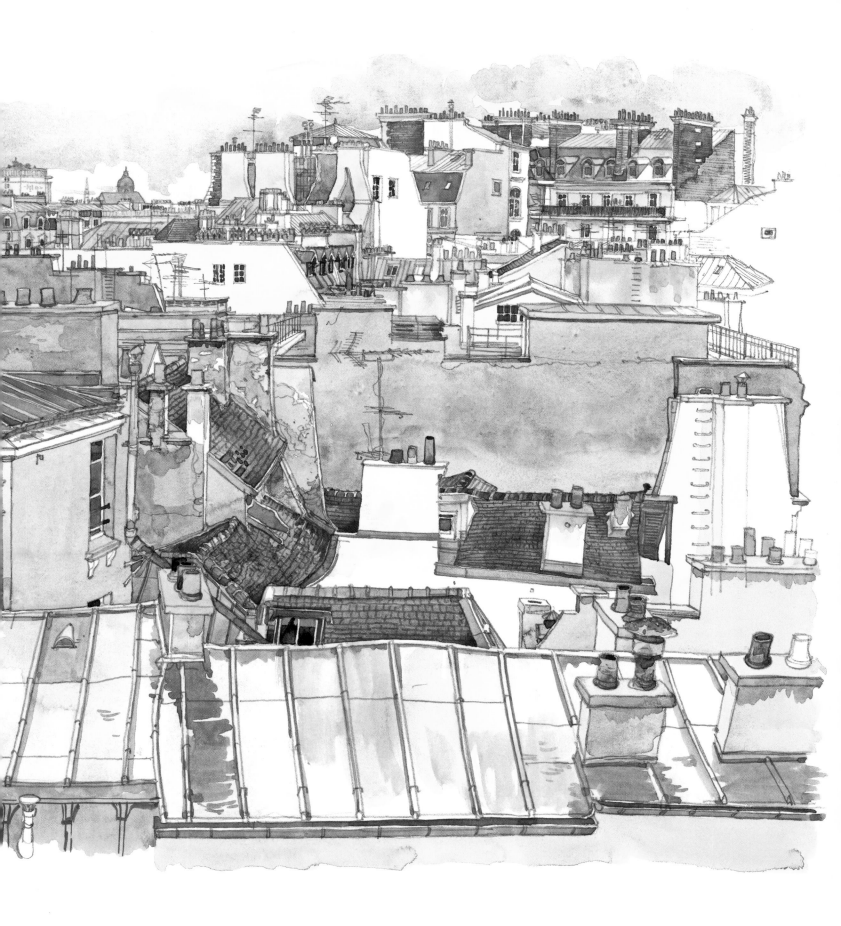

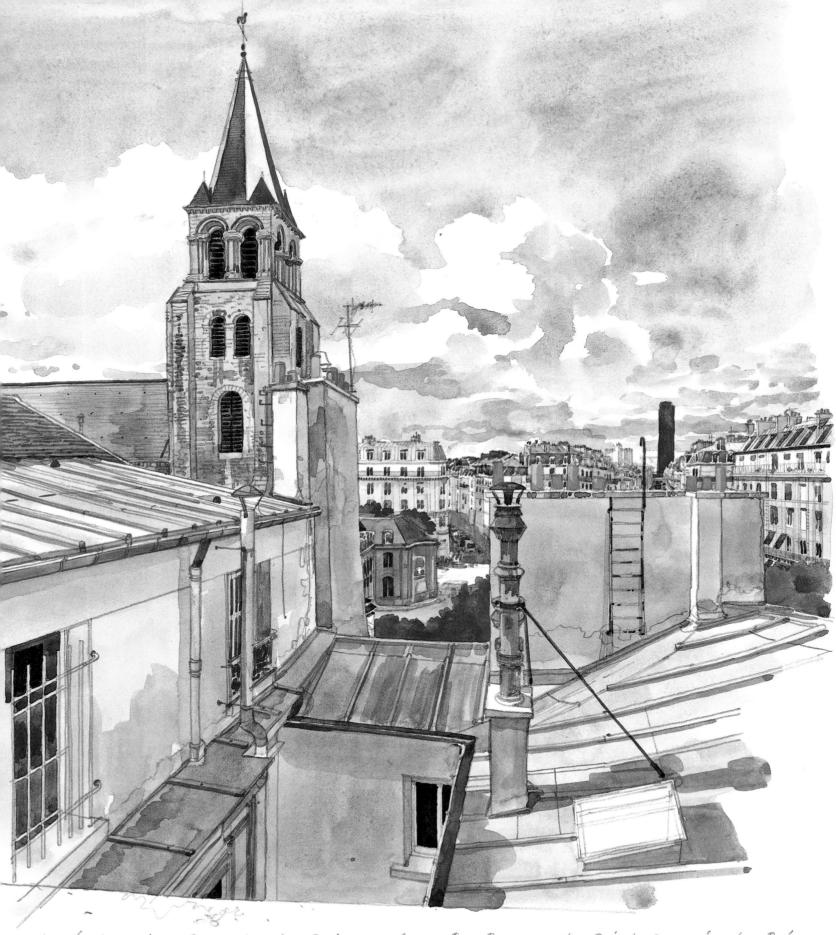

The Église Saint-Germain-des-Prés seen from Rue Bonaparte, Saint-Germain-des-Prés.

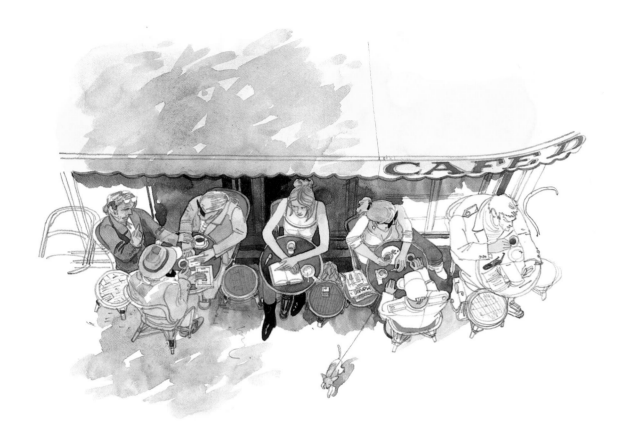

3

Literature viewed from above

She lays her hands on the table. They move by themselves, seizing a little space all around.
A light breeze that might be turned into a sentence could be captured with ease here
through the mechanism of her fingers. But the idea does not come. The lady sitting on the
terrace of the Café de Flore seeks inspiration, her gaze turning first to the boulevard, then
towards the church of Saint-Germain, and then up beyond the top of the building façades.
"Oh yes, how beautiful it would be," she exclaims to herself, "literature viewed from above!"

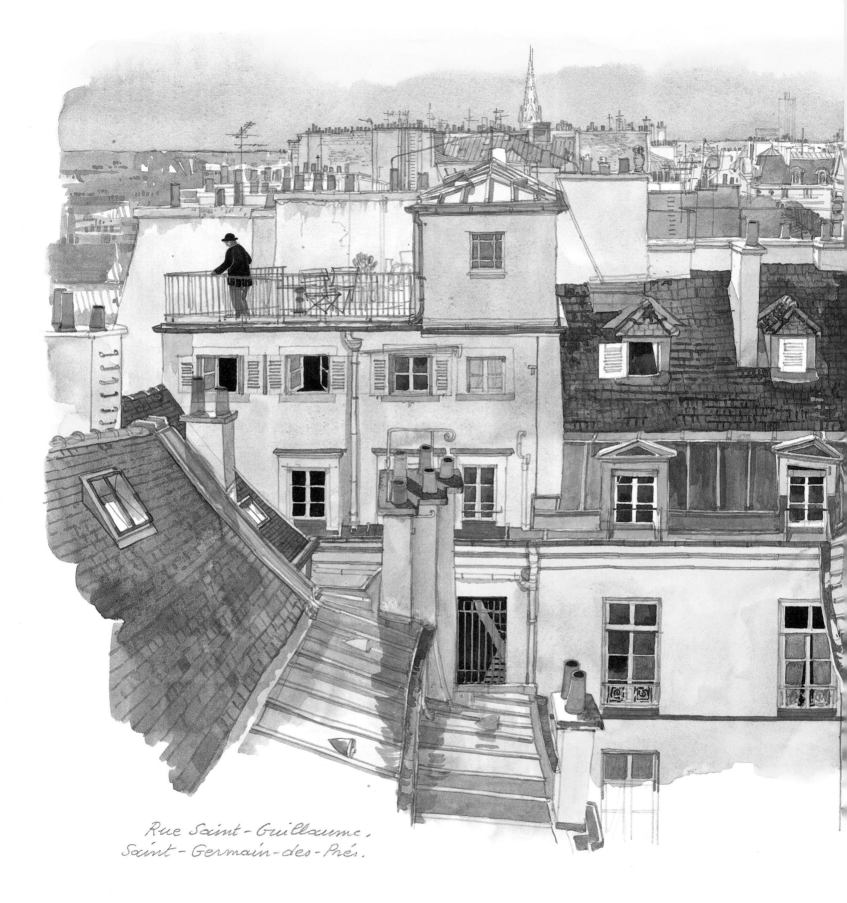

Rue Saint - Guillaume,
Saint - Germain - des - Prés.

4

Alcohol, tea and lemonade

Far from the Pont Mirabeau, eighteen metres above the Boulevard Saint-Germain, that is where Apollinaire spent his days, in search of his passport to the muses. He had a pigeon loft built, and named it the poets' perch, for liquor and lemonade parties. To see his smile, friends and the merely curious had to climb their way up six flights of a spiral staircase. A small opening in the wall, like a loophole in a fortification, served as password; up would pop Guillaume's head, or that of Pipe the cat. As the door creaked open, the visitor was faced with a helmet pierced with holes, glass balls, marionnettes, rickety chairs, calligrammes traced in dust, books piled up like beehives. Apollinaire was proud of this private retreat reclaimed from the roofs, which he had fitted up himself and decorated with two Matisse drawings. Picasso would arrive, and everything was laughter and daredevilry. They took a ladder to have tea at the very top of the lead roof, comparing their sense of vertigo, but not their fear of living. The other friend, Rouveyre, held back. He would say that he always found something threatening in the crowd of chimneys, with tops like helmets, which surrounded chez Guillaume.

5

Patina of the night

Patina of the night, the sound of water in a pipe,
dawn always coming too late or too soon. Looking
through the shutters, you arrange in your mind
your dreams, the façades far above the pavements,
the roofs shrouded in fog, seeming to sway
sometimes almost like skirts. It's time to get up.
The houses are up already. In Paris, they seem
never to have been asleep. Patina of the night,
a laugh on the stairway – and so you force yourself
to join the hordes of passers-by, the crowds on the
metro, in the the bistrots, in the narrow streets.
Today, the crowd will be beautiful.

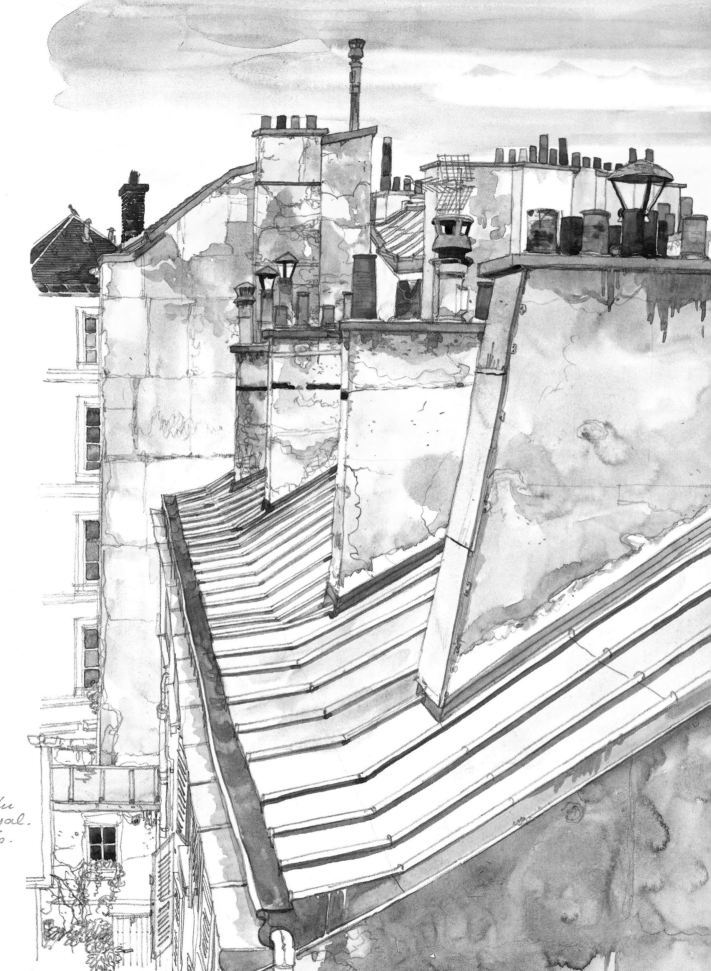

Rue du
Parc-Royal.
Marais.

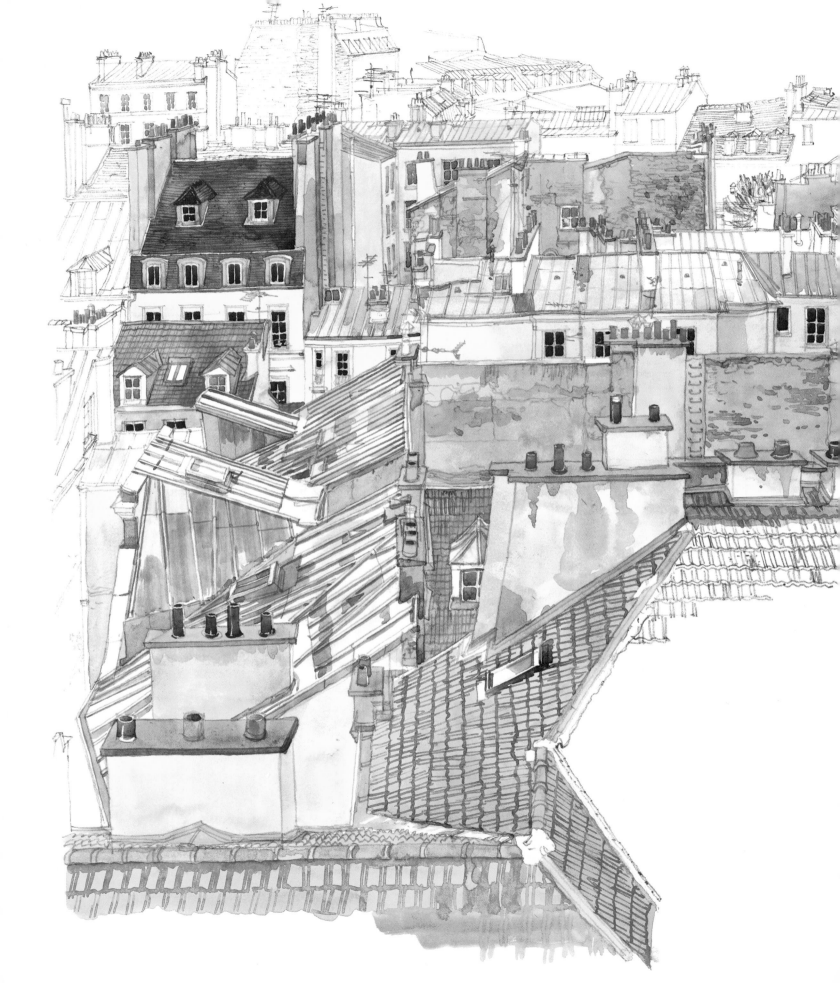

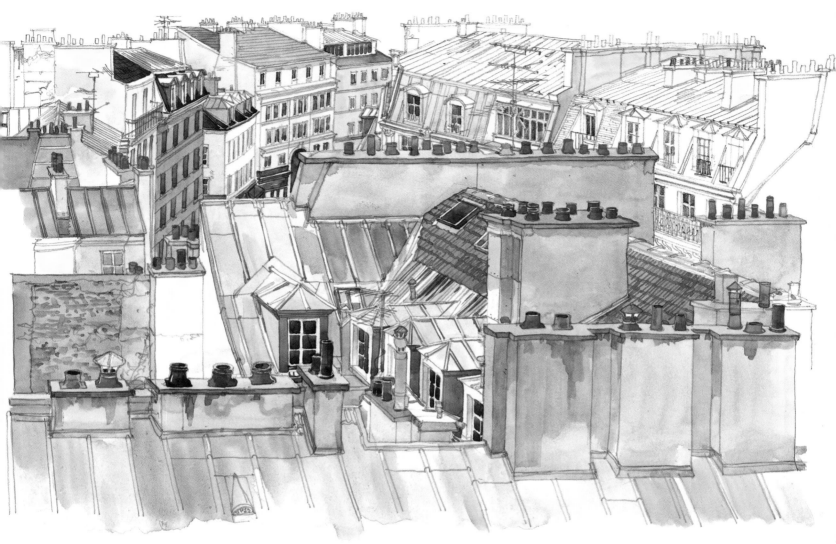

Passage Saint-Joseph,
Rue du Faubourg Saint-Antoine.
Bastille.

6

At a different height

You see life from up on the rooftops, there's no shade up here. The sky comes right down as if to eat out of your hand. You look at Paris as if through a long zoom lens, with its streets and alleys raised up or enclosed, running through the morning like wet furrows. You're aware of the sound of voices beneath these roofs and, at this moment, even against the noise of the city, now almost a continuous drone, you seem to hear them all. Paris shows her rooftops to those who will see them. In your mind's eye, a few pictures come to life, a bright reflection, a strand of sheer beauty, that immediately spark off other images. And suddenly, Paris is there in front of you, in all its magic, at an unfamiliar altitude.

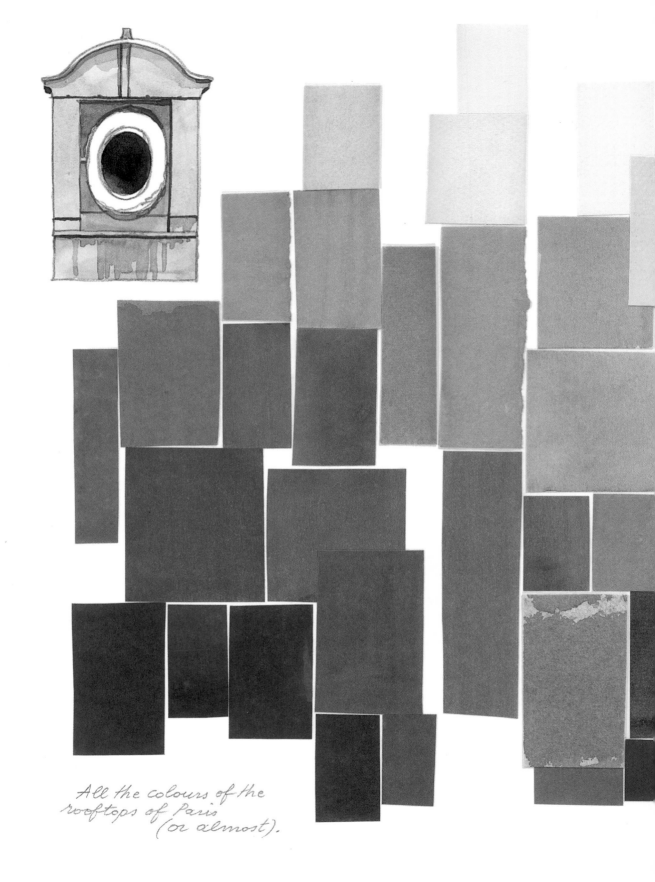

All the colours of the
rooftops of Paris
(or almost).

7

In praise of grey

At this modest altitude, it's time to speak out for grey, so often criticised for being monochrome, as if responsible for the greyness of peoples' spirits. What other colour has such subtle nuances? The roofs of Paris stand as unimpeachable witnesses, wherever they perch or lean. Sometimes greyish blues face the sky, verging on to beige; at other times, a touch of mauve-grey finds its way on to the upper reaches of the façades. And then the spectrum broadens, starting with the range of ochres, then that grey almost the colour of light clay, and the shadowy off-white caused by the passage of time, spreading across the rooftops as if to cover them with cloth. There isn't the slightest melancholy in grey. When the watercolourist lays a neutral grey, the first drop of terracotta to fall on it warms it up: a metamorphosis takes place from grey into a rooftop kingdom, a mysterious shadow-filled space or a mirror to reflect the merest dancing little cloud. And in the distance run the blue and red pipes of what looks like a big ship. This afternoon, that roof looks as if it has been dusted with flour, turning grey in the light. Perhaps, soon, even the Centre Georges-Pompidou itself will melt into its surroundings as part of this universal eulogy to grey.

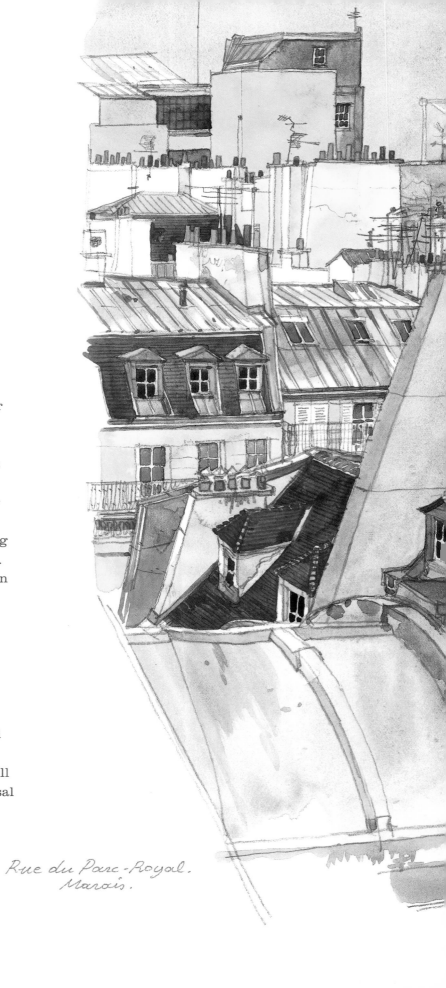

Rue du Parc-Royal.
Marais.

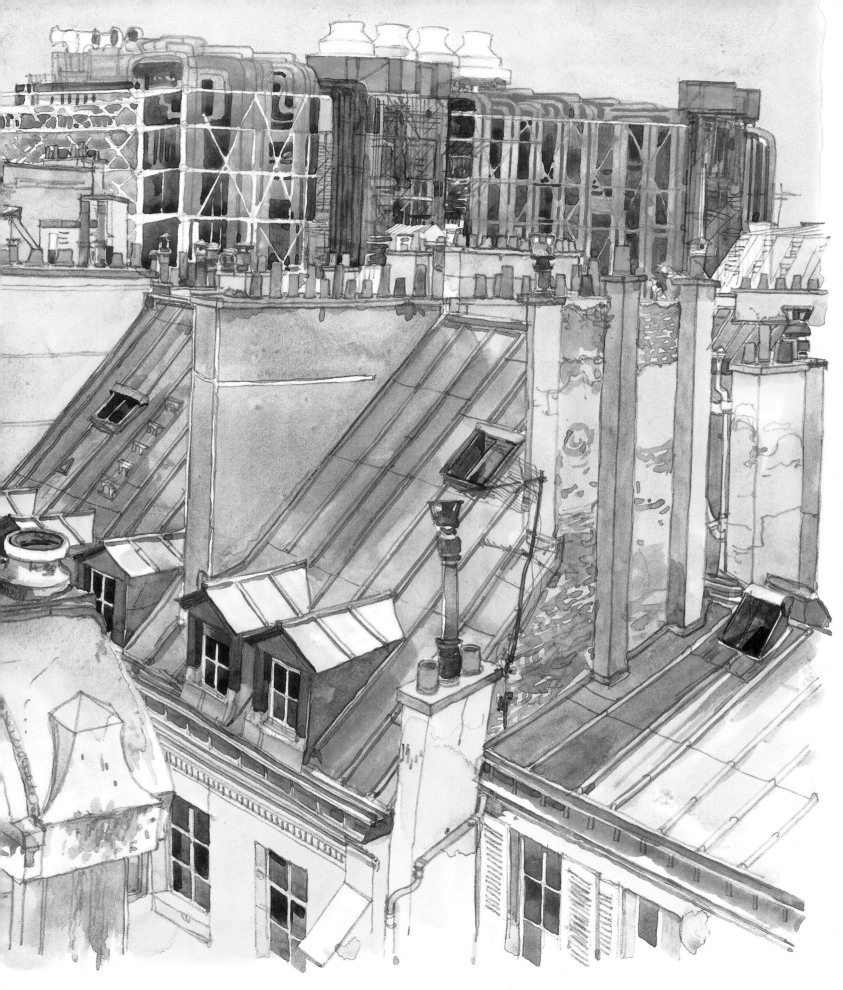

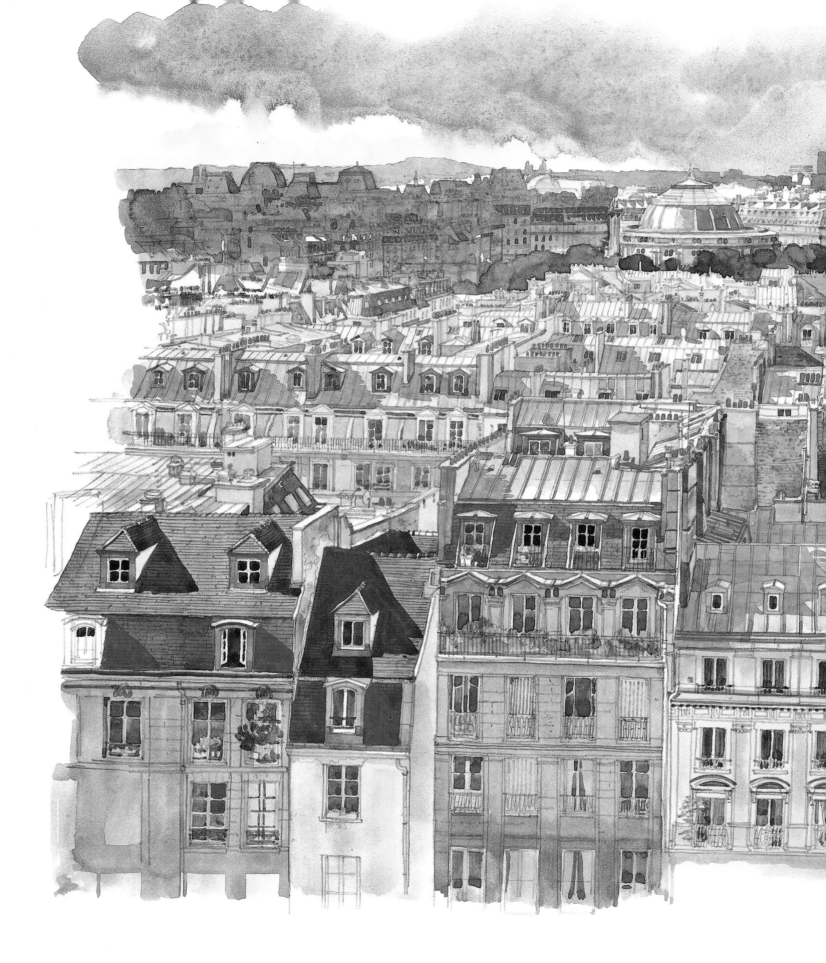

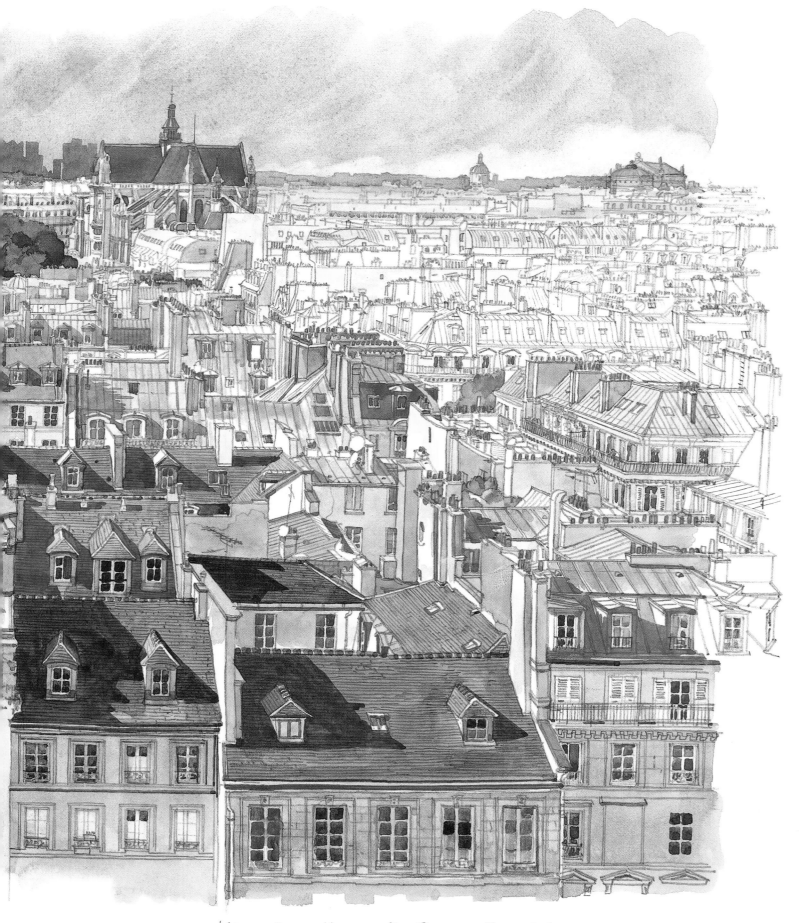

View from the Centre Georges-Pompidou.
The Louvre, Les Halles, the Église Saint-Eustache, La Défense, the Opéra-Garnier...

8 A colourful people

In Paris, there's a hidden people whose diverse, motley families happily rub along together. A people who speak during both day and night, and are always there, on rooftops, façades and squares, in the sky or down in the street. Who are these people? They are colours. In the building shown here in the painting, there lives someone who might be an ethnologist or he might just be a happy madman. At his feet or, rather, before his eyes live the beige people, ecru or chalky-white depending on their mood, the ochre people, extending to pink when required, the blue people, twirling, running down onto high walls punctuated by warm, orangey-brown chimneys. It's good to leave the land of shapes for that of the one people ablaze with colour.

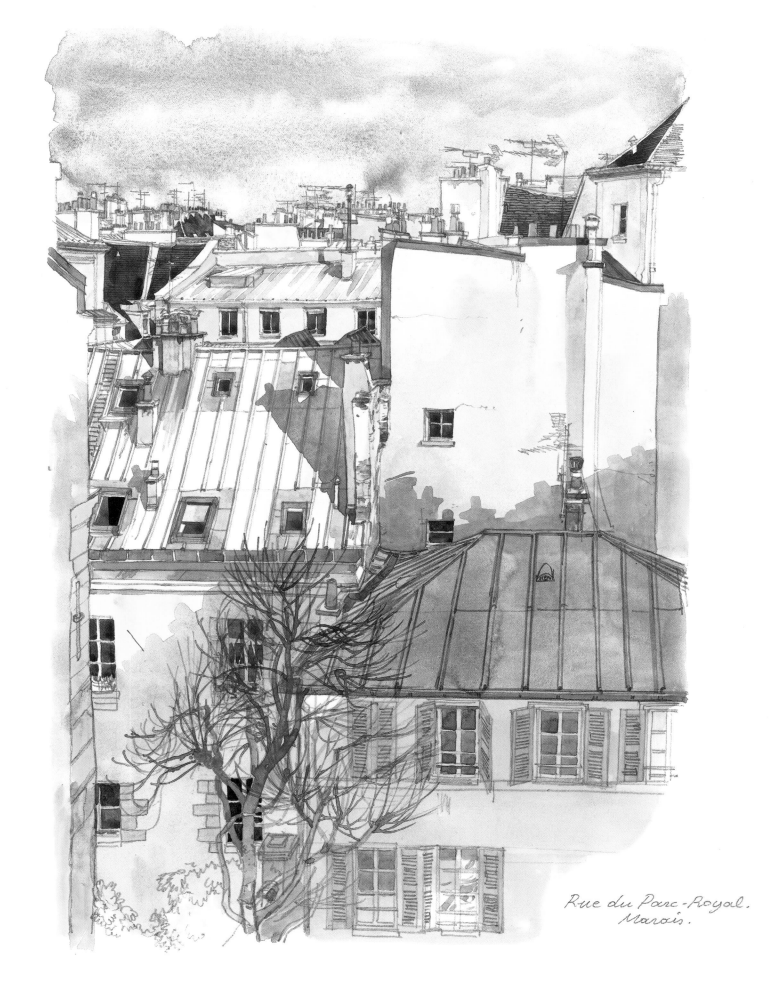

Rue du Parc-Royal.
Marais.

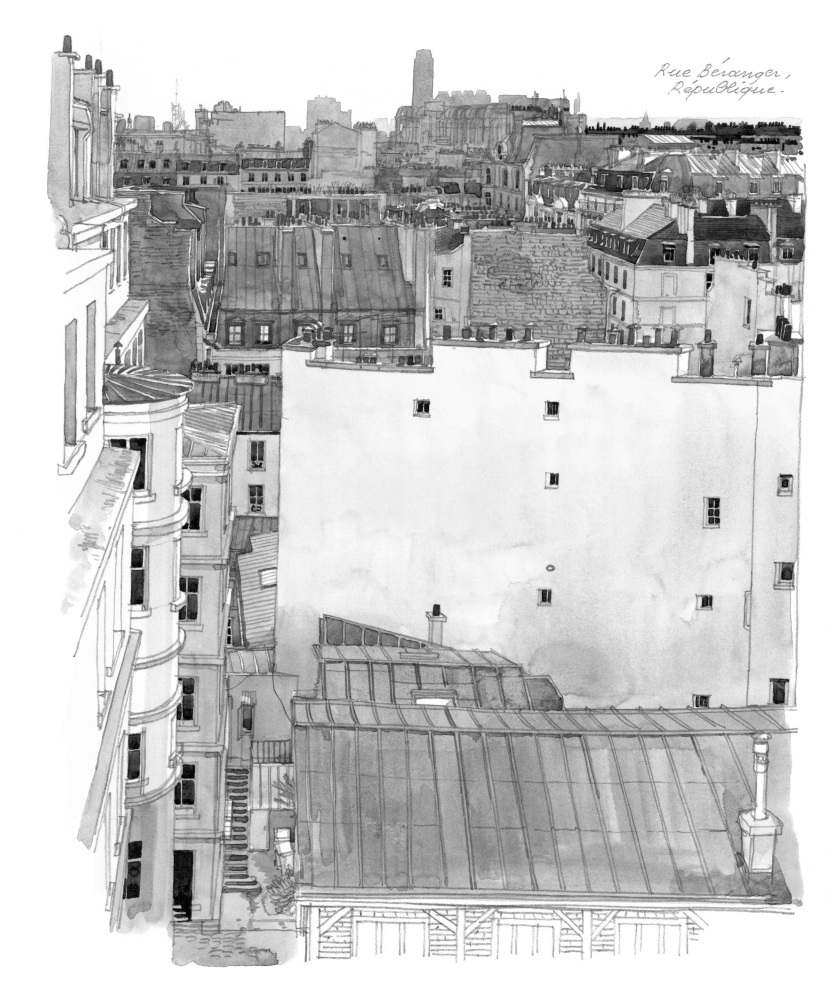

Rue Béranger,
République.

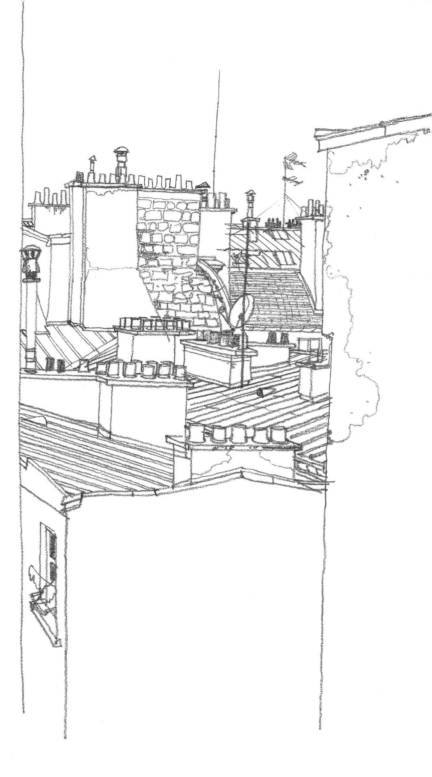

9

Fortress

On a wall which looks like a fortress, the sun refuses to set. Spreading lazily over the façade, it creates its own desert landscape, revealing all manner of sandy hues. Further away, the shadows have their own realm in the Rue de Bretagne and the Square du Temple, towards Beaubourg. Thanks to a slow parting of the clouds, the fortress is set ablaze, bright and clear as a page on which can be recorded easily the time left for each of us simply to while away, or to use gainfully in the contemplation of a single image.

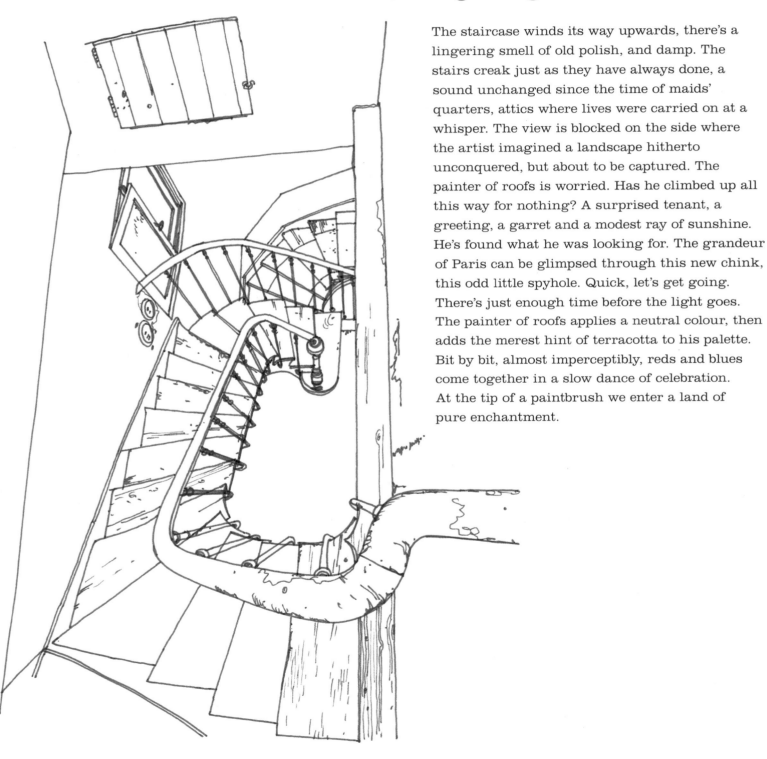

10 Flight to light

The staircase winds its way upwards, there's a
lingering smell of old polish, and damp. The
stairs creak just as they have always done, a
sound unchanged since the time of maids'
quarters, attics where lives were carried on at a
whisper. The view is blocked on the side where
the artist imagined a landscape hitherto
unconquered, but about to be captured. The
painter of roofs is worried. Has he climbed up all
this way for nothing? A surprised tenant, a
greeting, a garret and a modest ray of sunshine.
He's found what he was looking for. The grandeur
of Paris can be glimpsed through this new chink,
this odd little spyhole. Quick, let's get going.
There's just enough time before the light goes.
The painter of roofs applies a neutral colour, then
adds the merest hint of terracotta to his palette.
Bit by bit, almost imperceptibly, reds and blues
come together in a slow dance of celebration.
At the tip of a paintbrush we enter a land of
pure enchantment.

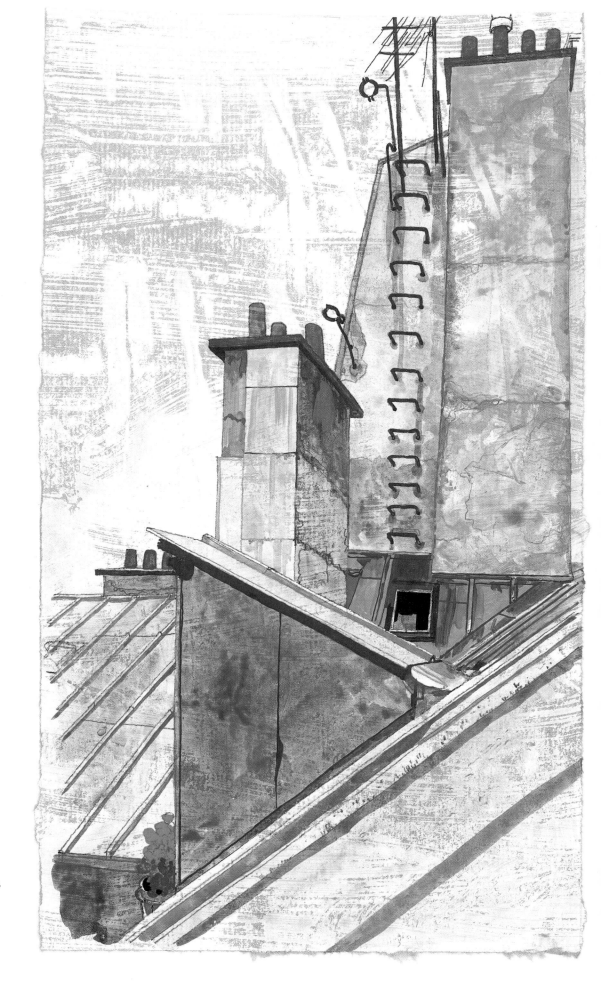

11

One step closer

Everybody knows about poets in Paris, living in garrets, suffering and penniless. But has anyone considered that under that attic roof the poet was just a little closer to the sky?

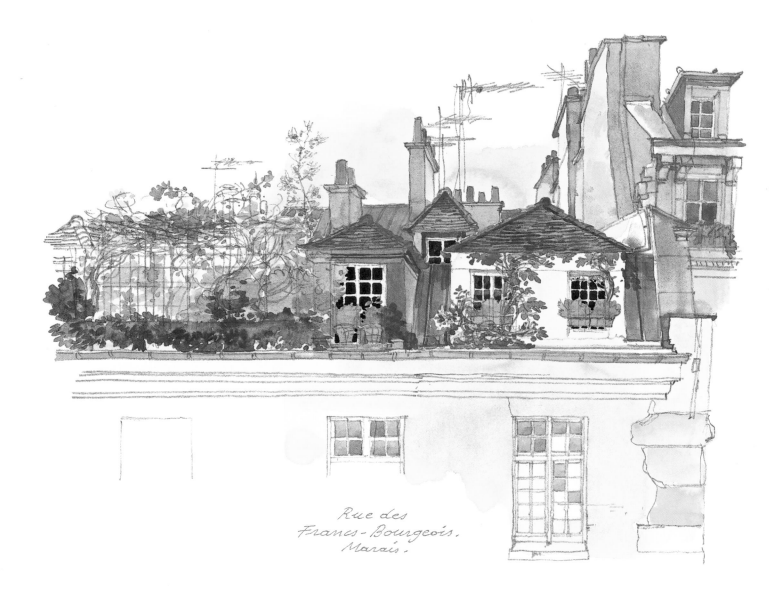

*Rue des
Francs-Bourgeois.
Marais.*

12

The tame jungle

We're all sparrows at heart, flying over part of the city, over houses huddled closely together as if trying to keep warm, or leaning on each other like unstable rows of dominos, when suddenly we spy a patch of green. An oasis hanging in the air, flowerpots lined up like targets in a shooting gallery, where, beneath bamboo pergolas, plants colonise space as slowly as a bird building a nest. Geraniums, boxwood, ivy, flashes of colour, little dashes of fragrance, everything competes for supremacy in the deepset streets or on the façades of aristocratic houses in the Marais. We're all sparrows at heart, especially when we spot the growing tendril of a creeping plant or, perhaps in our imagination, a secret corner where a tempting blackberry or a hidden raspberry trembles on its stem.

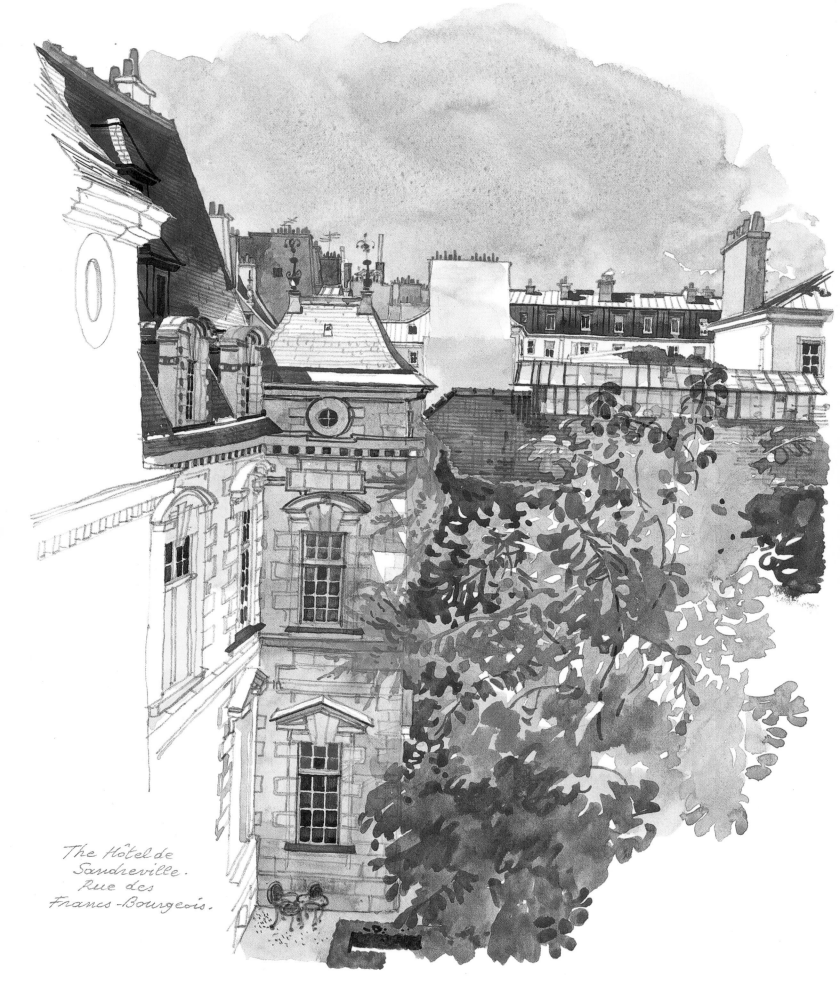

The Hôtel de
Sandreville.
Rue des
Francs-Bourgeois.

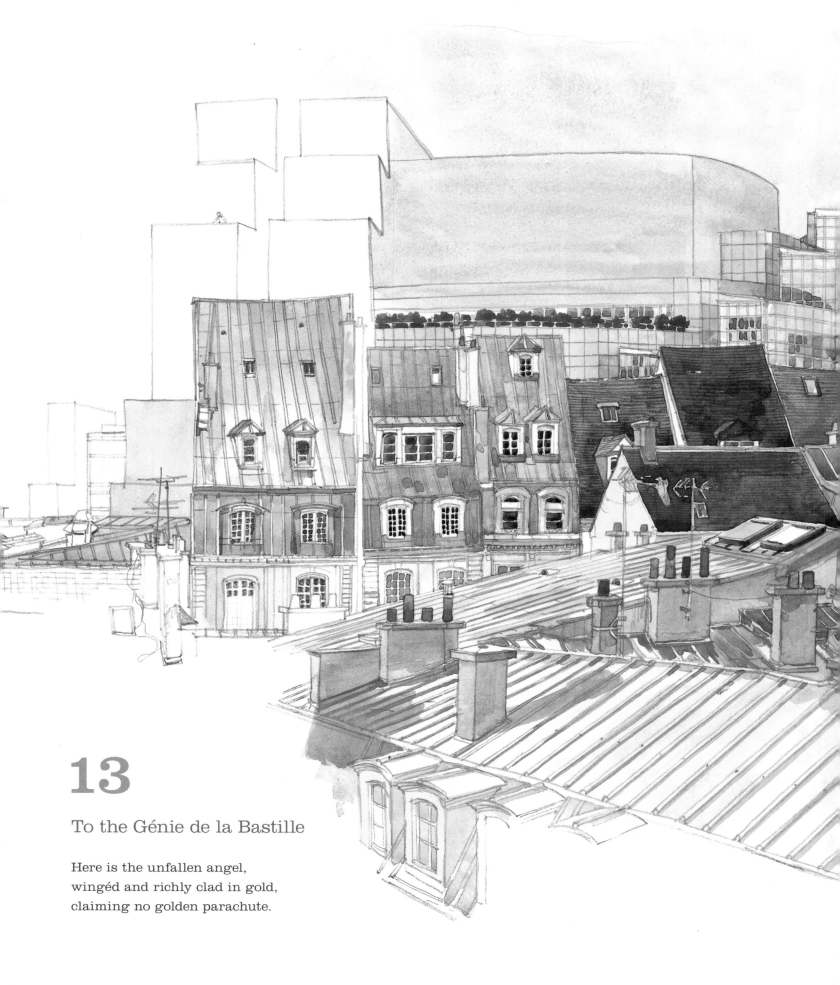

13

To the Génie de la Bastille

Here is the unfallen angel,
wingéd and richly clad in gold,
claiming no golden parachute.

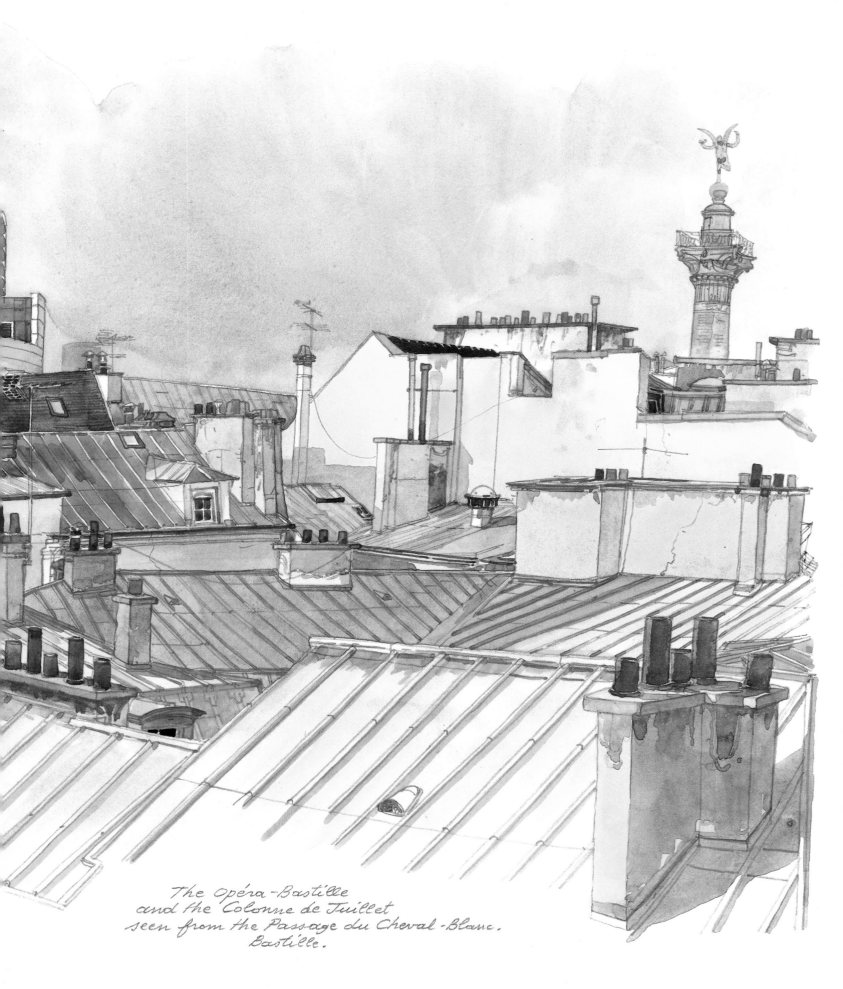

The Opéra-Bastille
and the Colonne de Juillet
seen from the Passage du Cheval-Blanc.
Bastille.

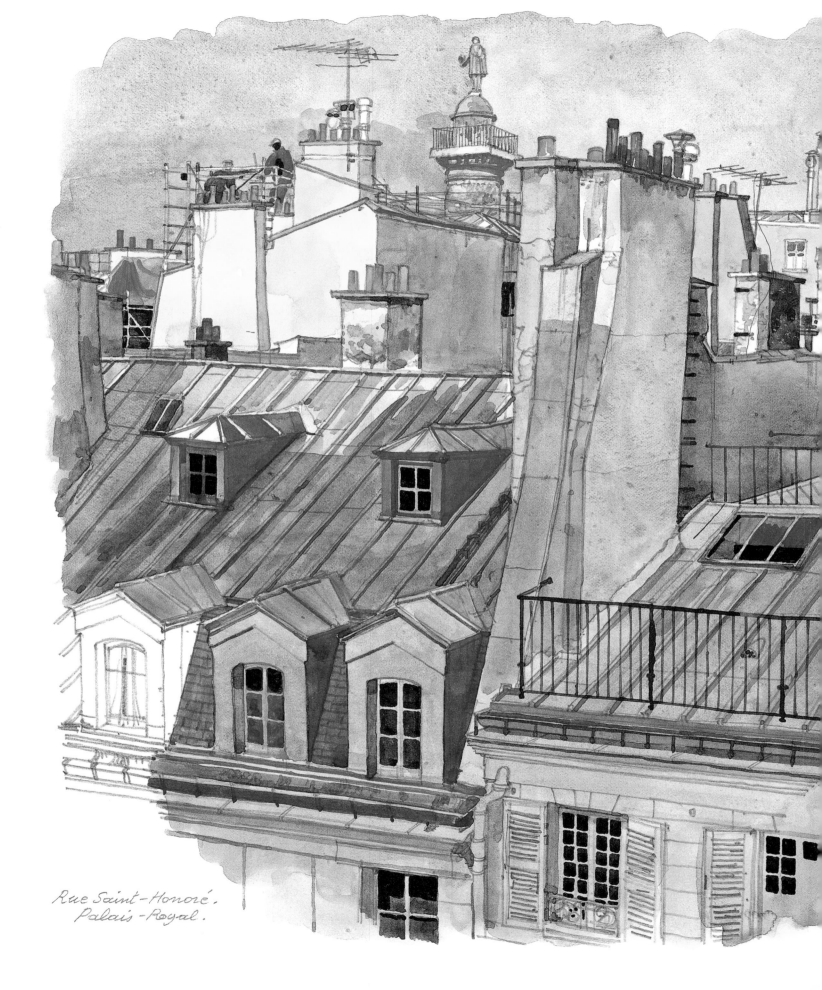

Rue Saint-Honoré.
Palais-Royal.

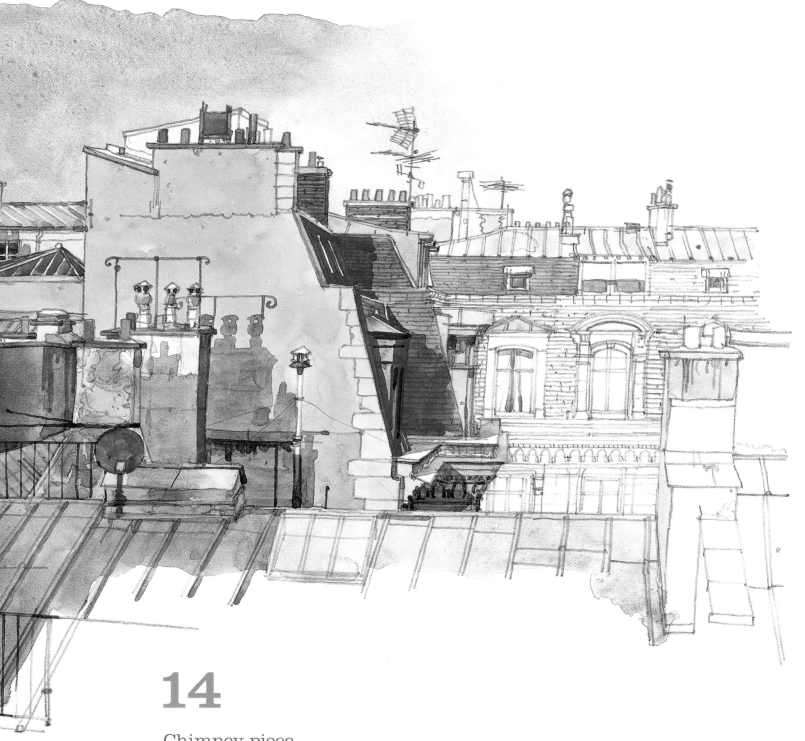

14

Chimney piece

Two roofers are busy at work. A broken chimney-pot no doubt. Behind them is the Vendôme Column, as indifferent to their presence as to those who came before them, brought down at the time of the Commune, then raised again like a slender lighthouse. The men work on the stonework, while looking down on the square, where chauffeurs wait in front of shop windows, brushing the dust off their vehicles. Children's voices rise up from the Rue Saint-Honoré. The city is at times humming, at times seeming to pause for reflection. The limousine starts up. The chimney-pot is back in place and the world moves on.

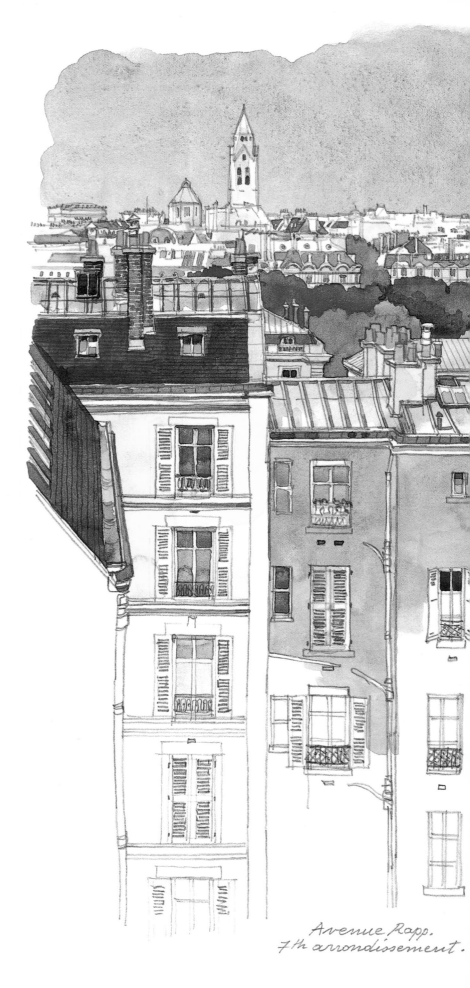

15

The hidden Seine

If our eyes were able,
to wander about at ease,
to roam among the chimneytops,
and among the far-off trees,
no alley would we see below,
but the river Seine in hiding,
invisible from where I'm perched.
From high in an attic dormer,
I imagine it beneath the green,
stretched out like a slumbering cat.

Avenue Rapp.
7th arrondissement.

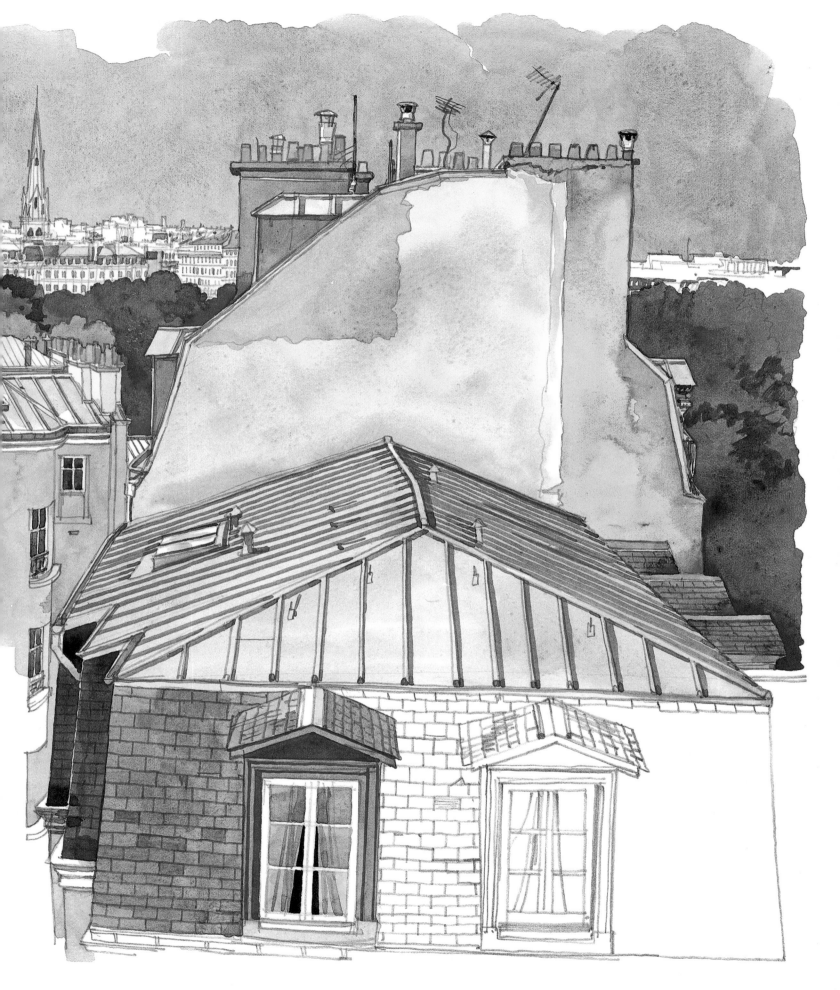

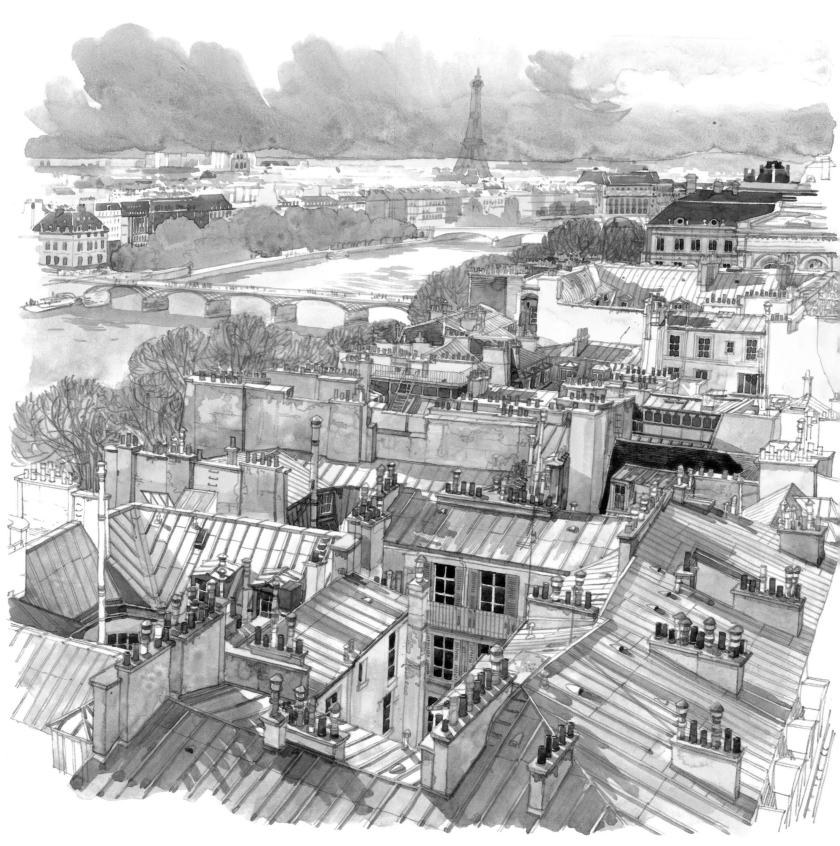

From up on the terrace
of la Samaritaine.
1st arrondissement.

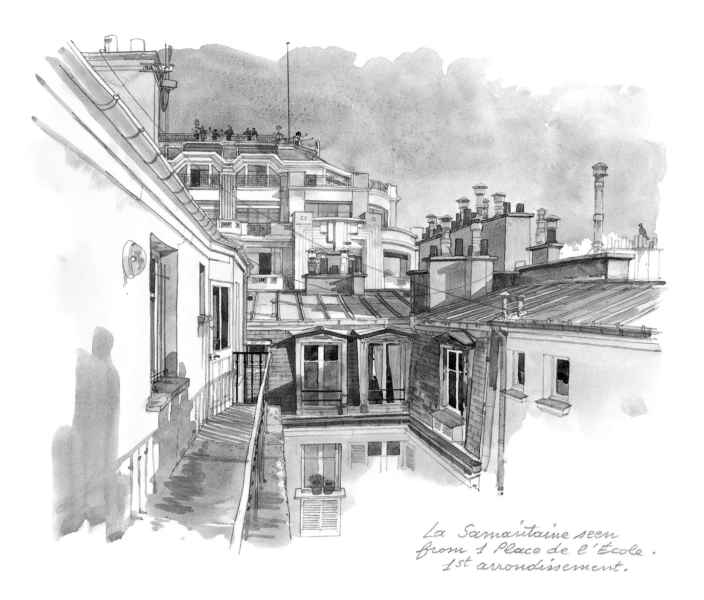

La Samaritaine seen
from 1 Place de l'École.
1st arrondissement.

16

Postcard to a roof

From La Samaritaine, the distant views are like postcards. At one glance we can see
the Eiffel Tower, the Pont des Arts and a corner of the Louvre. But then, if we let our
imagination be fired by the perspective, if our focal length is shortened, another world
appears: an accumulation of honeycombed courtyards, a crenellated stack of chimneys, a
delicate islet of tiles surmounted by a portico. A landscape trapped in the afternoon light,
in which the spirit can wander.

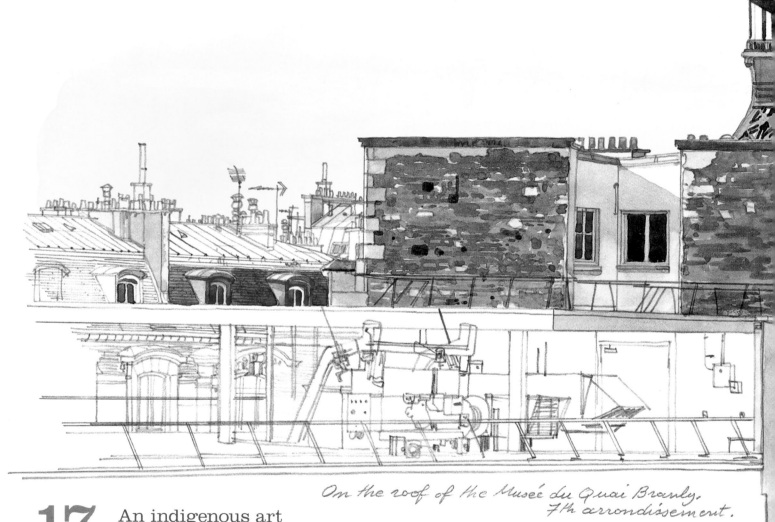

On the roof of the Musée du Quai Branly,
7th arrondissement.

17 An indigenous art

Seen from Musée du Quai Branly, here are the feet of one of the tallest totem poles in the world, neither kachina nor tupilak, its interwoven metal gigantic and menacing, its tip challenging the heavens. From up here, Monsieur Eiffel's creation never fails to disconcert the eye, familiar though we are with idols.

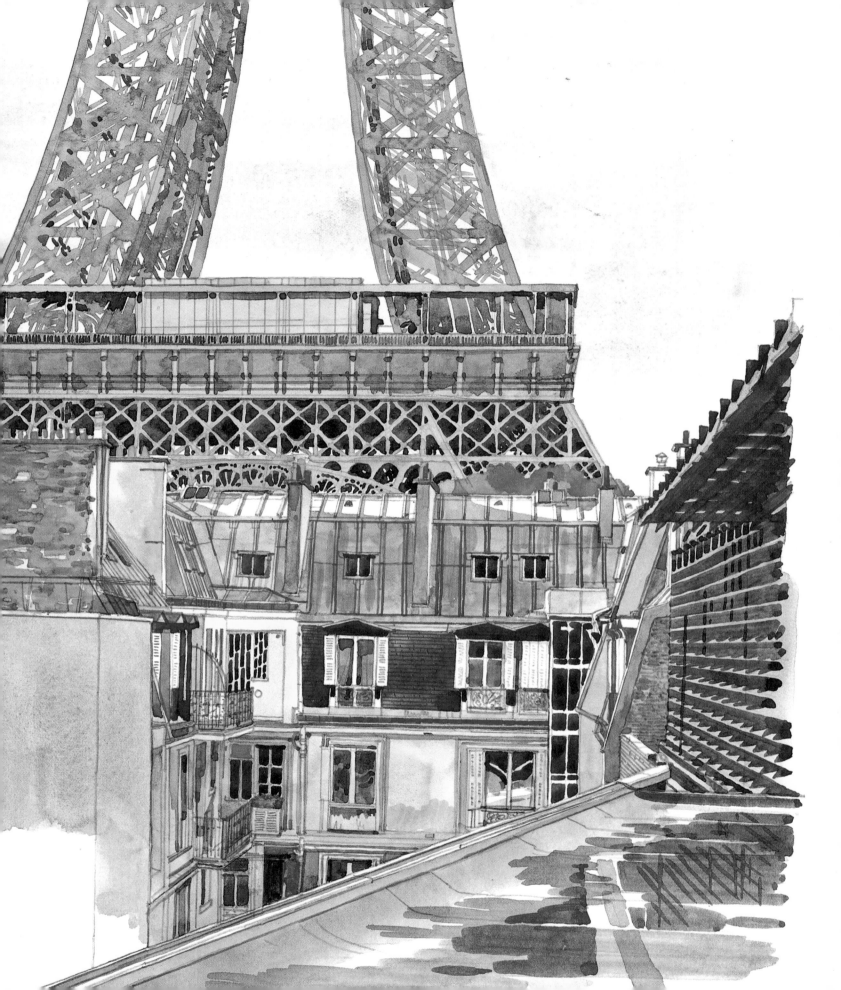

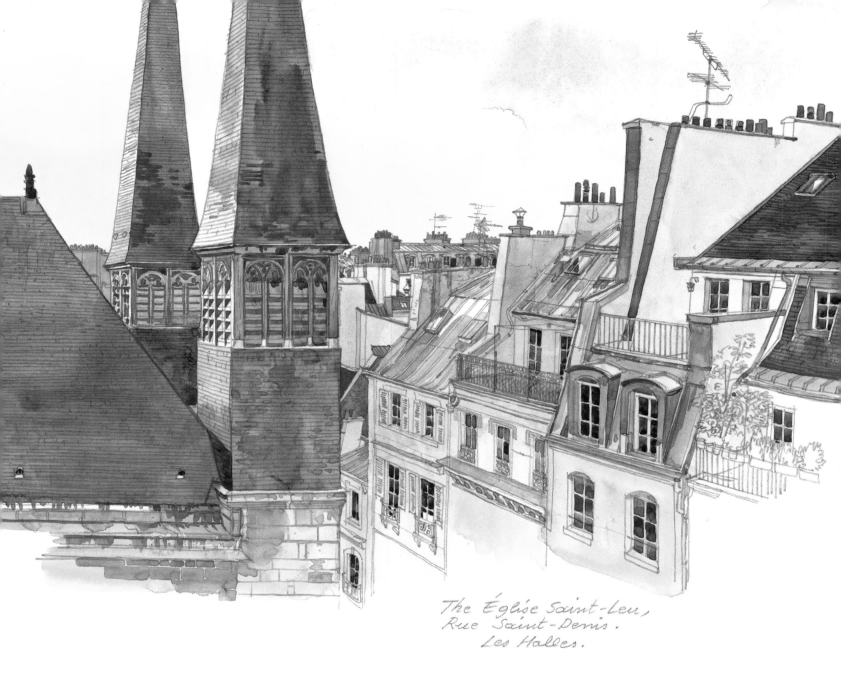

The Église Saint-Leu,
Rue Saint-Denis.
Les Halles.

18

Guinguettes and cheap wine

At the tollgates, where those who were refused entry to the city once made their homes, a veritable kingdom flourished: illegal traders, small-time innkeepers, smugglers of cheap wine to be drunk on the spot or taken away, assorted low-lifes and prostitutes, ruffians with dodgy names, pushy policemen, shady merchants, all pressing up against the walls of Paris. Sometimes, the air above the Porte Saint-Denis or elsewhere is filled with lost souls, traces of wine fumes, words, wrongs that will never be put right, and laughter from the rooftops too loud ever to disappear.

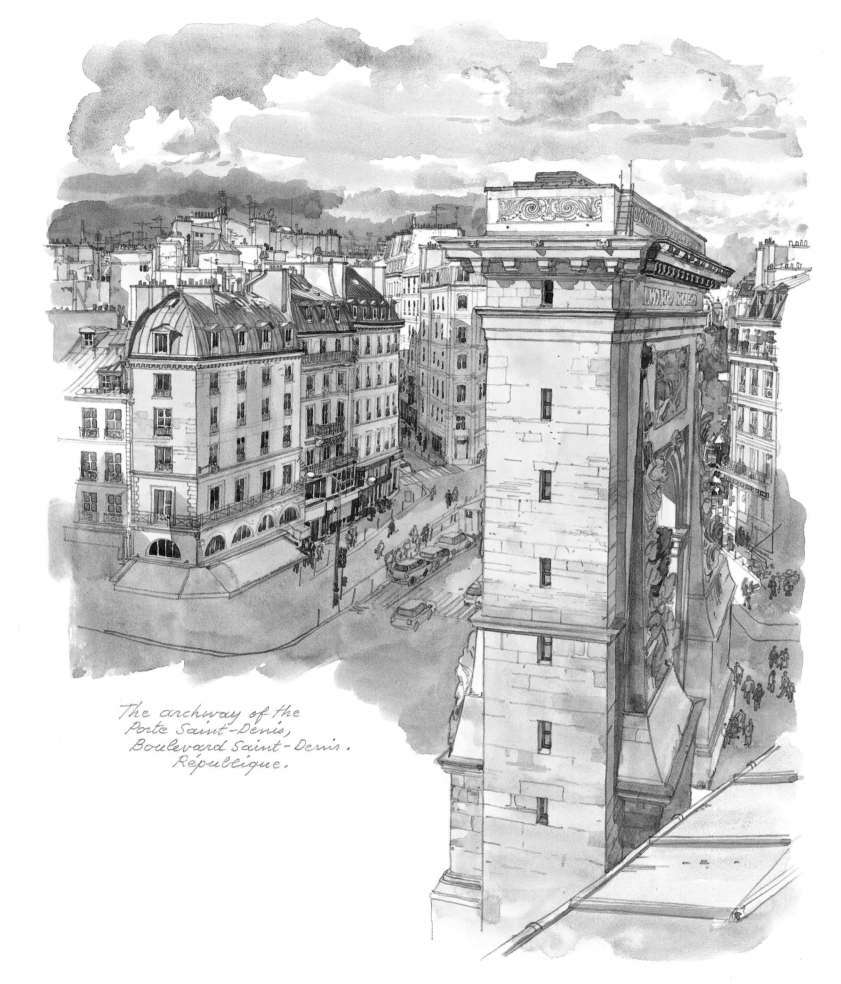

The archway of the
Porte Saint-Denis,
Boulevard Saint-Denis.
République.

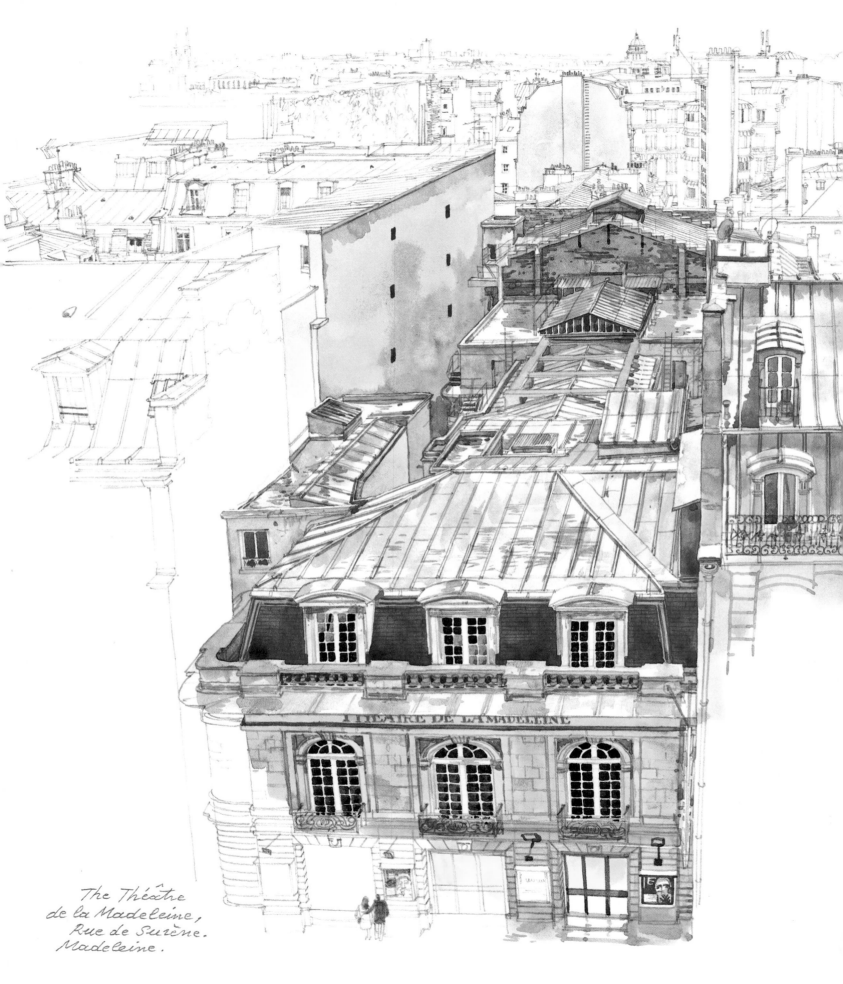

The Théâtre
de la Madeleine,
Rue de Surène.
Madeleine.

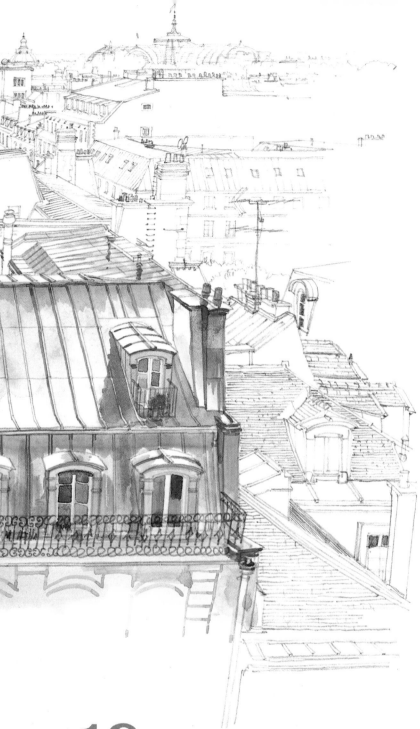

19 Guitry's La Madeleine

Some ghosts dress better than others. Never at rest in their white sheets, they laugh eerily and slam doors. At the Théâtre de la Madeleine, few remember Pagnol; it was here that Sacha Guitry became a legend. Making regular appearances, this ghostly figure with hat and pince-nez can sometimes be seen haunting the stage or taking a stroll along the gutters, repeating over and over again that comedians must be taken seriously, and adding, as he disappears, leaving behind a whiff of cigar smoke: "To be Parisian is not to be born in Paris, but to be reborn there."

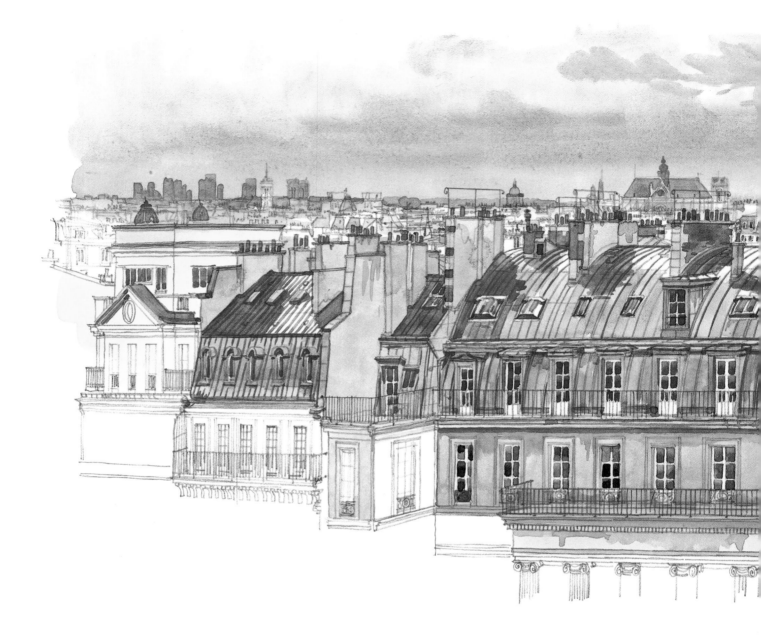

20

Room with a view

In late 1831, drifting down like an autumn leaf, Frédéric Chopin arrived in Paris, still disorientated by the uprisings in his homeland, with a little soil in his pockets taken from the Poland he would never see again. He first made his home at 27 Boulevard Poissonnière, just beneath the roof. "Many people envy my view, but none my stairs," he wrote in a letter. From the balcony, the ultimate luxury, he could see Montmartre and the Pantheon. Up there, he was able to draw breath, looking over the Paris that he was set to conquer, with an urgent desire to live and breathe in harmony with the city while there was still time.

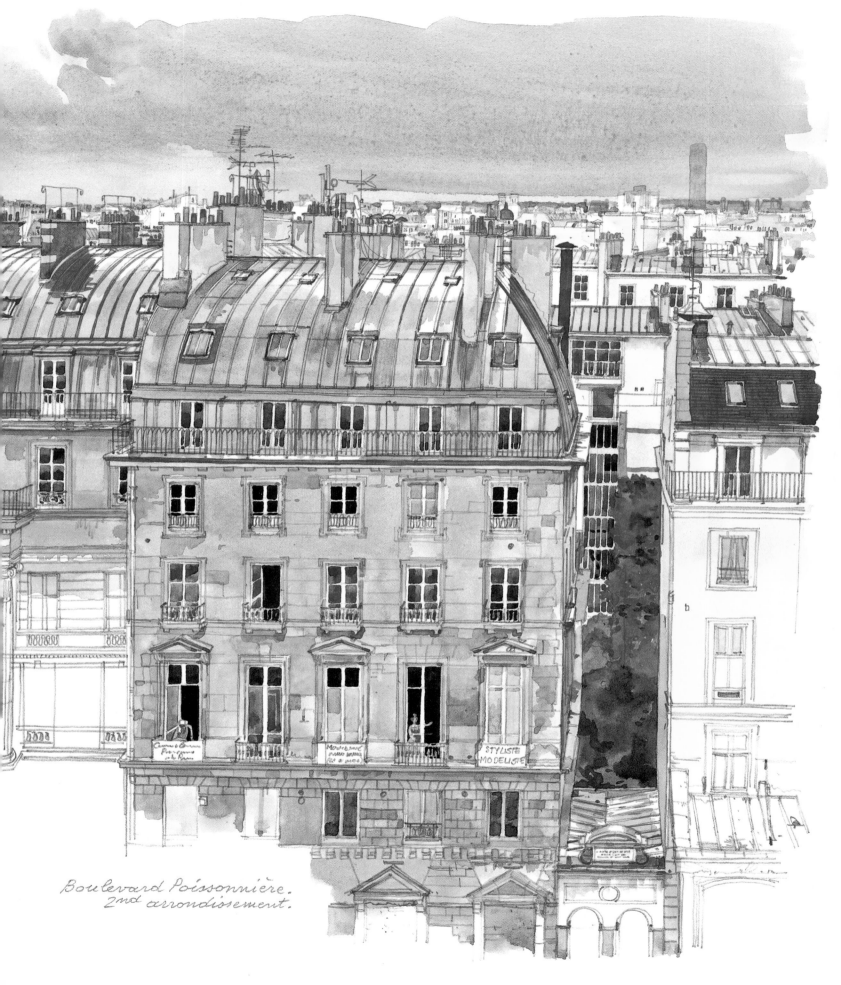

Boulevard Poissonnière.
2nd arrondissement.

21

Paris for a blonde

Under the sun, the roofs turn into mirrors or zinc tabletops. Our eyes wander slowly across the scene. High up, the chimneys are shaped like bishops' mitres; we notice the cowls like little gnomes, and other concrete headwear. We imagine ourselves having a picnic on the ridge of the sloping roofs, surrounded by a few plants. A few birds – the less grey ones – will come to peck at the crumbs. The melody of an old song wafts upwards and suddenly a blonde girl gets up and dances in the sun. The blaring old refrains continue as evening falls. And gradually, we feel a little more love in the air.

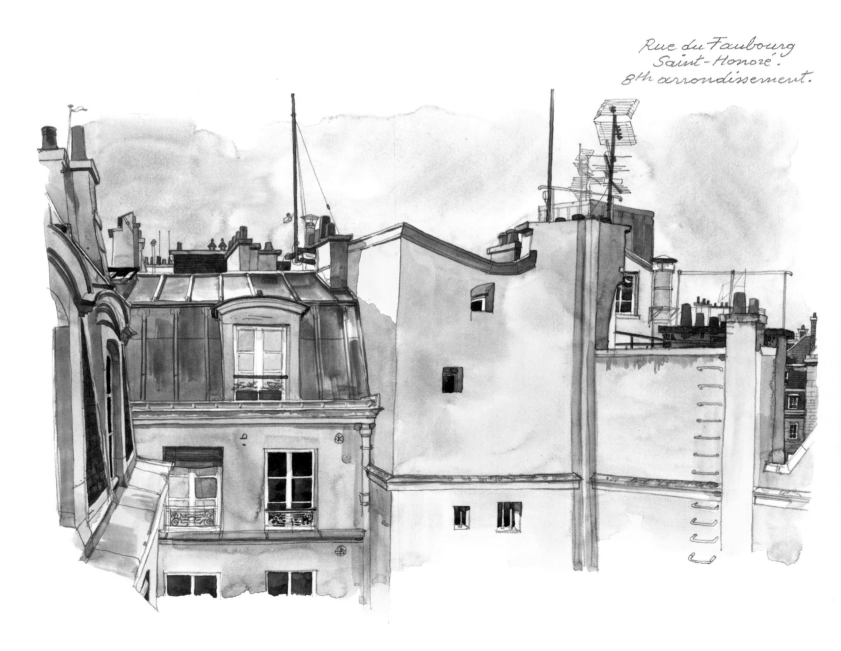

Rue du Faubourg Saint-Honoré. 8th arrondissement.

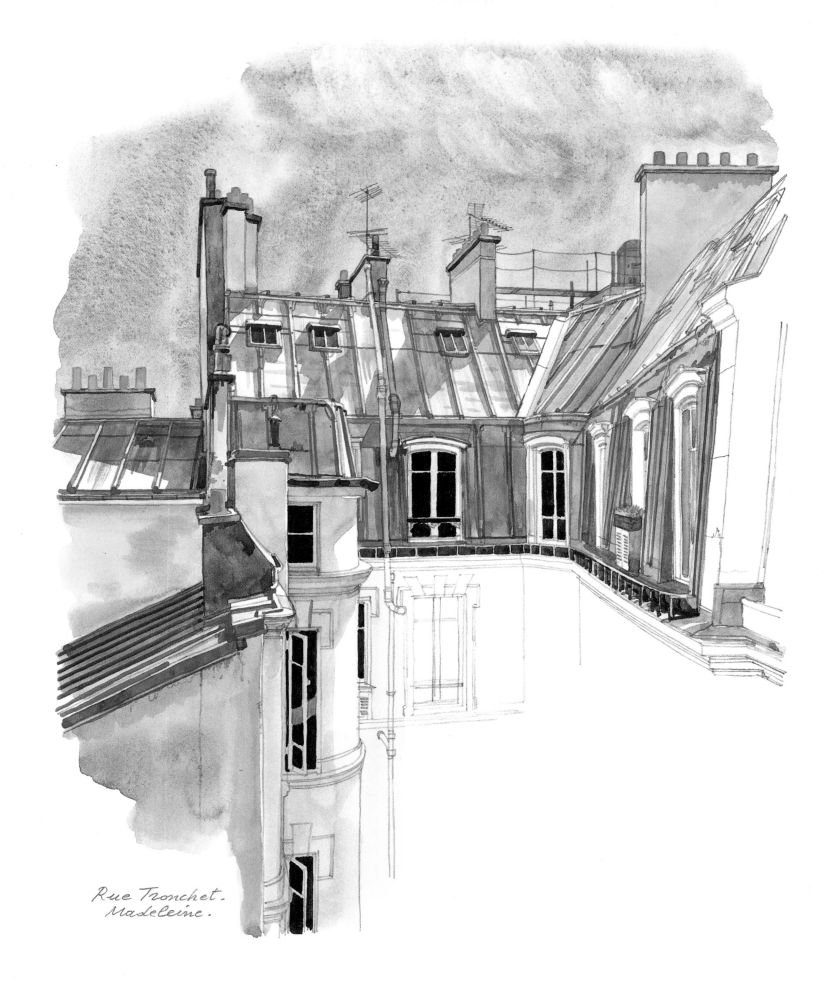

Rue Tronchet.
Madeleine.

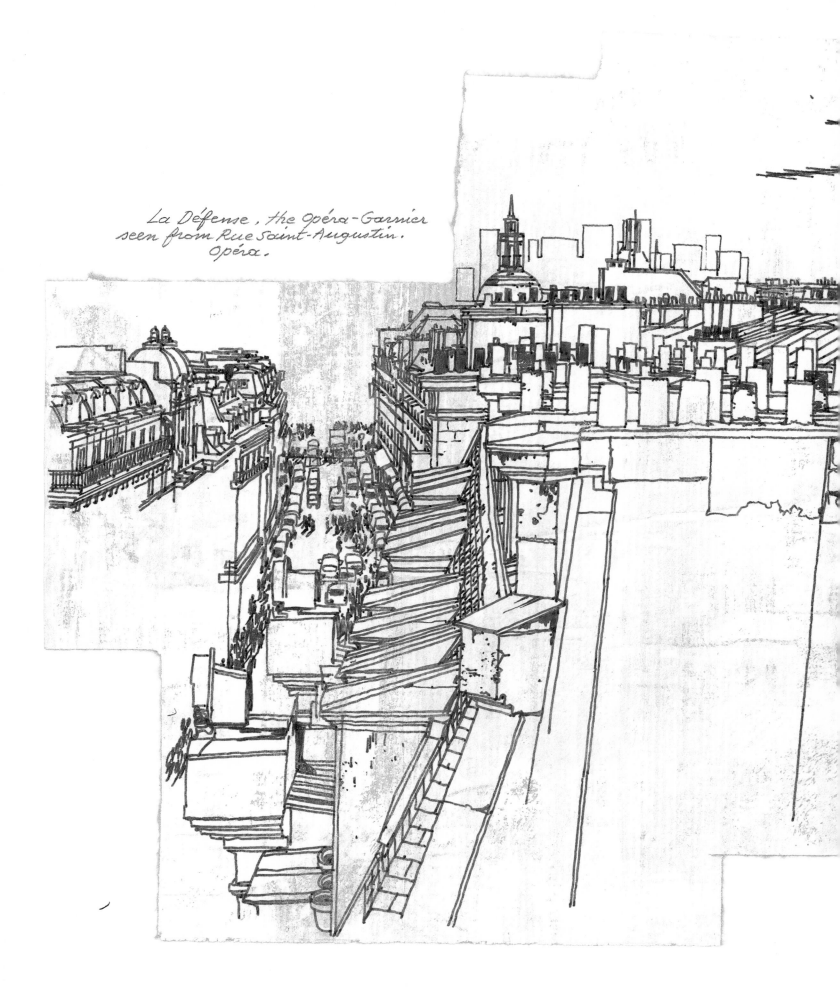

La Défense, the Opéra-Garnier
seen from Rue Saint-Augustin.
Opéra.

22

Commuters

At ground level, they are commuters. Seen from up on the roof, they form dense ant-like swarms, as shoulders jostle, caps and hats come face-to-face, heads of hair move as if in a wind that isn't really there. I contemplate these chasers after time. I steal an hour from them, they take only a moment from me. People stream out of the metro at Bourse and Opéra, in no particular formation, frozen in the early morning; but from this height, what a beguiling sight, like the surface of fabric in the sunlight! The commuters follow their lives like people throwing a dice time after time, without ever playing the game. Minor introspections are their fate from the moment dawn breaks. At times, some of them pause briefly and seem, from up here, to have a moment of doubt, before rearranging their briefcases and setting off again, caught in the act of existing in the world's very flesh.

23

To the music-loving bee

The honey of Paris is priceless, people say. But here the bees are music lovers. They swarm to the latest concerto, abuzz with debate over the merits of Mozart's or Dvorák's flights of fancy. Long after their ancestors displayed their finery in the Jardin du Luxembourg more than a hundred years ago, these sunny insects have made their home on the roof of the Opéra-Garnier. Their penthouse hives have their own musical scores, and the nectar that these beauties seek out, far from the pesticides used in the countryside, is said to produce a honey purer than that from anywhere else. When a double bass is bored with playing or a minuet goes round in circles, the bees compose a fugue, flying off to the lime trees in the Palais-Royal, seeking out pagoda trees, even lavender. Honey, like music, is enriched by contrasts, mixtures and detours. Beneath the roof and all around, both singers and insects improvise. Not the flight of the bumblebee, but the song of a journey from the soul to the ear, from flower to mouth.

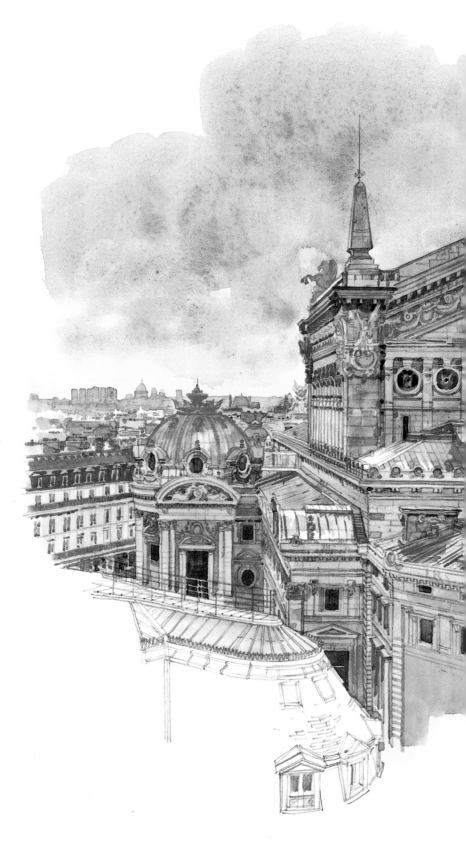

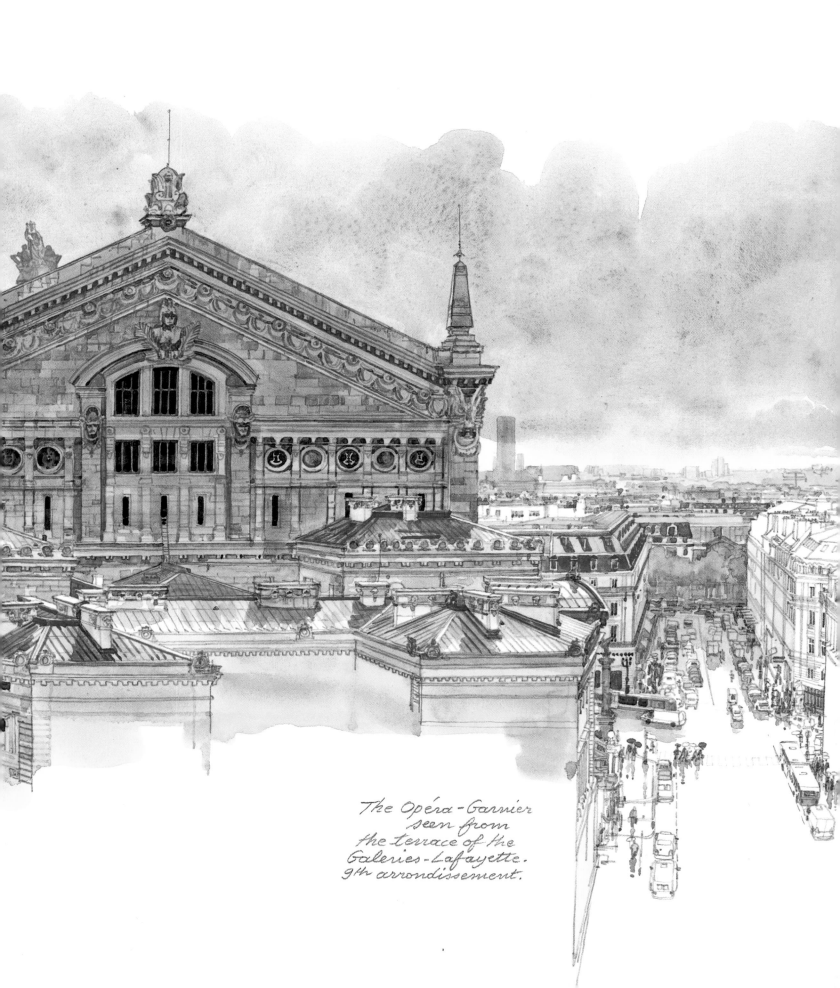

The Opéra-Garnier
seen from
the terrace of the
Galeries-Lafayette.
9th arrondissement.

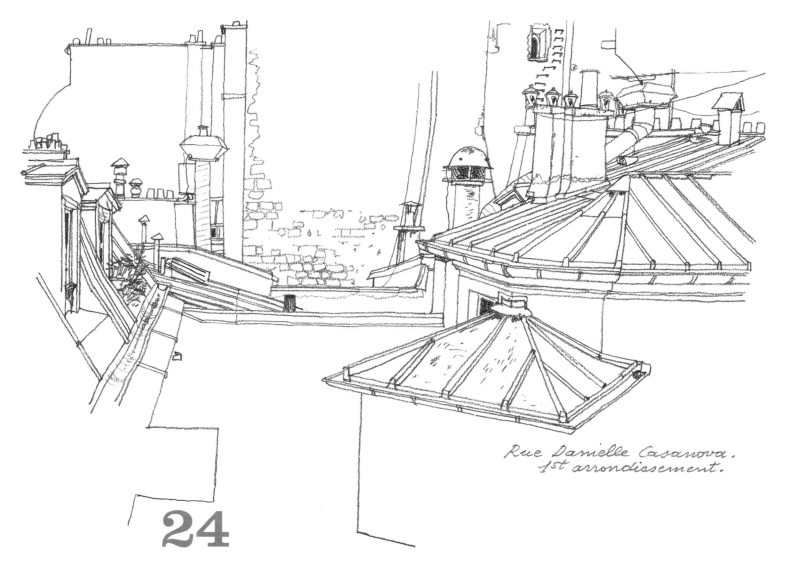

Rue Danielle Casanova.
1st arrondissement.

24

Stacks of chimneys

These chimneypots, lined up like onions or a battle formation,
are not an army on the run,
nor forgotten pawns from a chess game,
nor neglected skittles as yet unfallen,
nor glasses toasting themselves at a party of invisible guests,
nor tubes for unlikely messages in an old pneumatic mail system,
nor sockets for missing lamps intended for mystics to light up the sky,
these chimneypots are simply notes
from a seven- or eight-line score,
a minuet or, even better, a fugue.

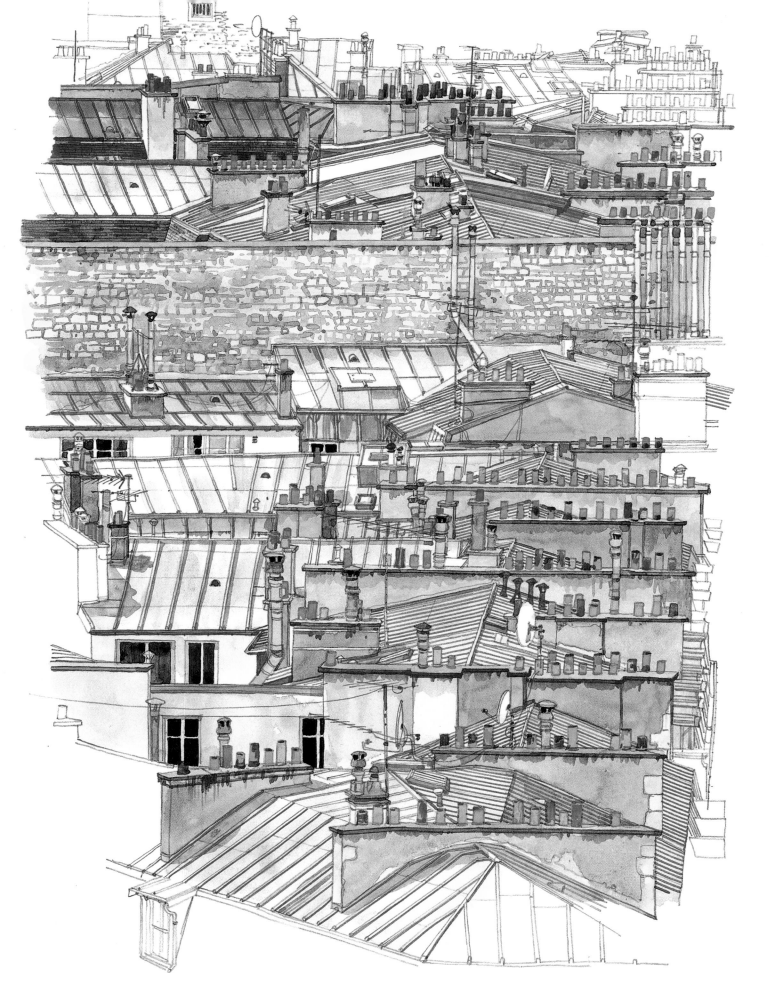

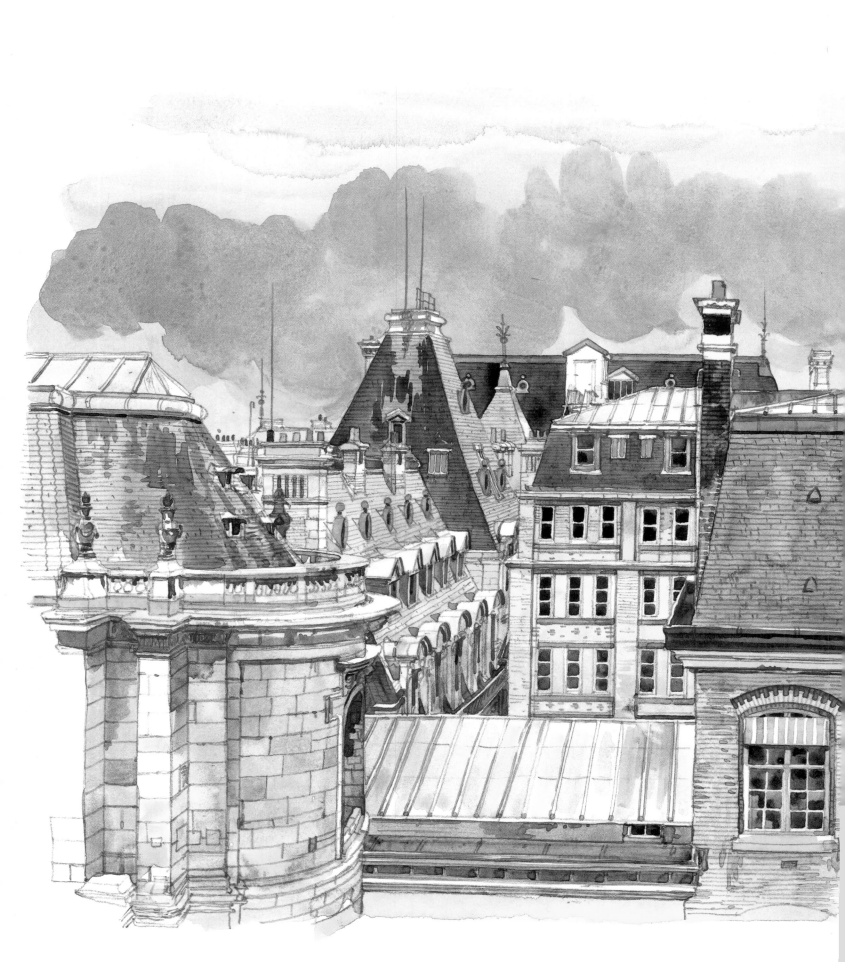

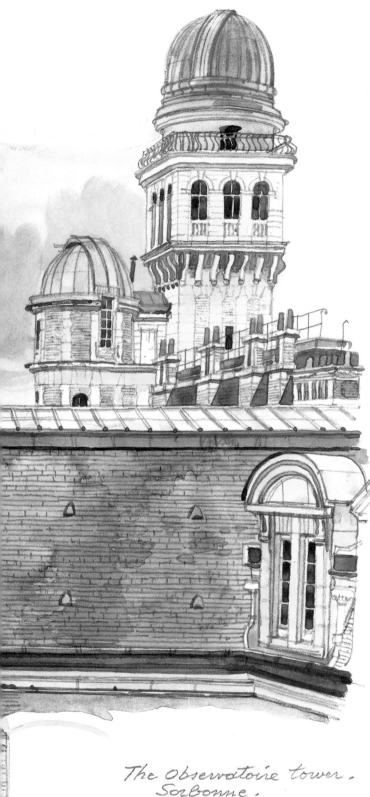

The Observatoire tower.
Sorbonne.
Quartier latin.

25

The favour of the stars

Paris, city of light. Everybody knows that. And the Paris of five-star hotels. But what of the heavens above? For this, you need to go for a look around the roof of the Observatory. Under the dome, the openings are for a telescope that has served well over time. The instrument was not that of a cyclops, a creature with one eye. It was here that one Monsieur Cassini, as much magician as optician and astronomer, created the first map of the moon. With his lens, one perfectly clear night, he observed the satellites of Saturn and the way its rings were arranged. From up on this roof, a voice seems forever to ring out with the words:

> "This is the Grand Equatorial speaking,
> please dear stars, can we meet,
> throw caution to the wind,
> and shine over Paris for a moment,
> city of light within a sea of lights."

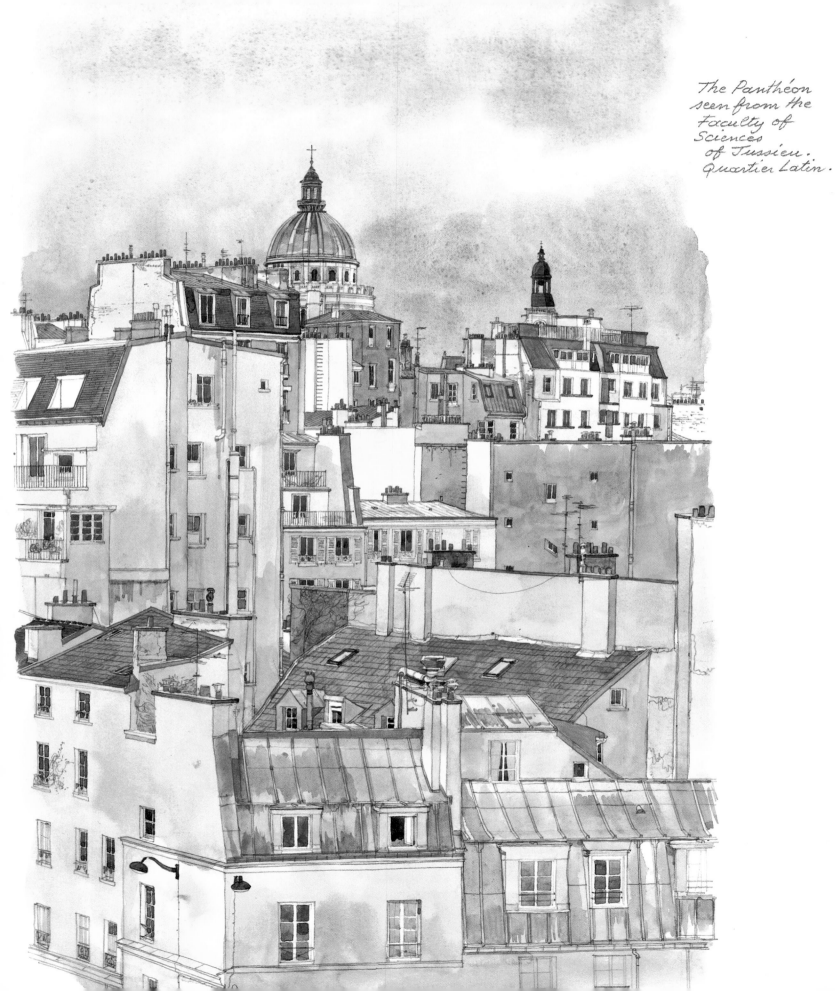

The Panthéon
seen from the
Faculty of
Sciences
of Jussieu.
Quartier Latin.

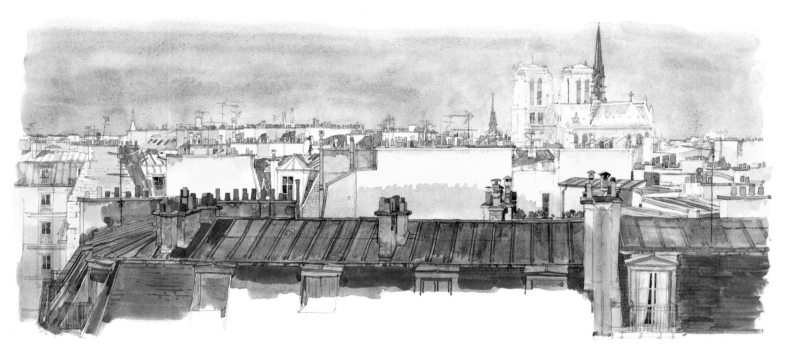

Rue des Fossés-Saint-Bernard.
Quartier Latin.

26

Portrait of a sightless person

The blind man who speaks of the roofs never mentions the silence of his eyes. His voice is high enough to rise above the pavement. His expressive hands, especially, evoke curves and gables. His fingers mimic crumbling, rubble, sometimes in contrast to solid stone or metal arches. His profession? When asked, he replies sky-tuner or tight-rope walker. His palm looks scarred in one place. Touching the roofs, sometimes clawing like a cat, caused the damage to his hands. Or at least that's what he says. He tells anyone who cares to listen that he played at being immortal on the dome of the Panthéon. He even likes to recount how he spent a night chatting with the gargoyles high above Notre-Dame's nave. "Only the birds never lie," he adds, gently smoothing his mop of hair.

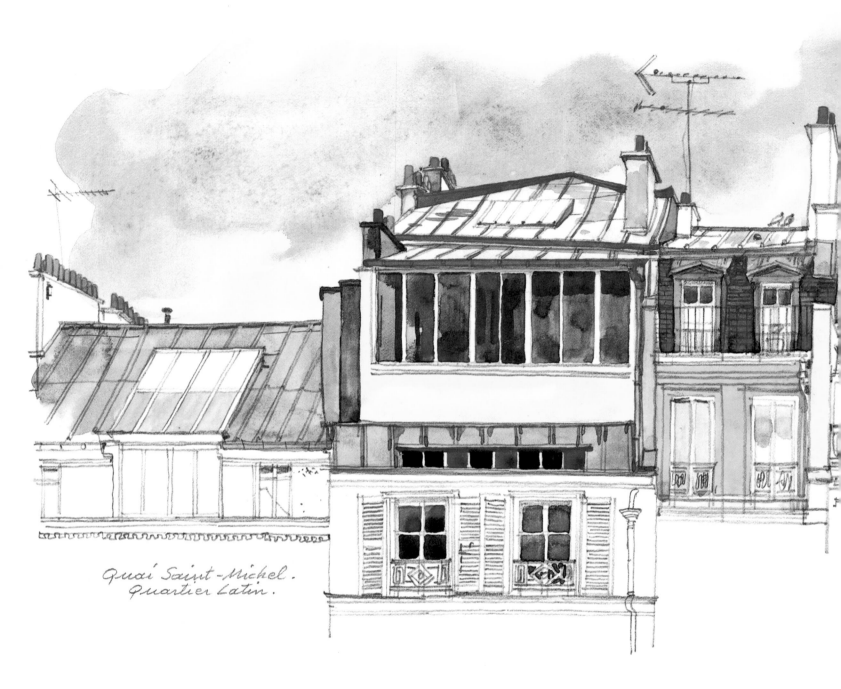

Quai Saint-Michel.
Quartier Latin.

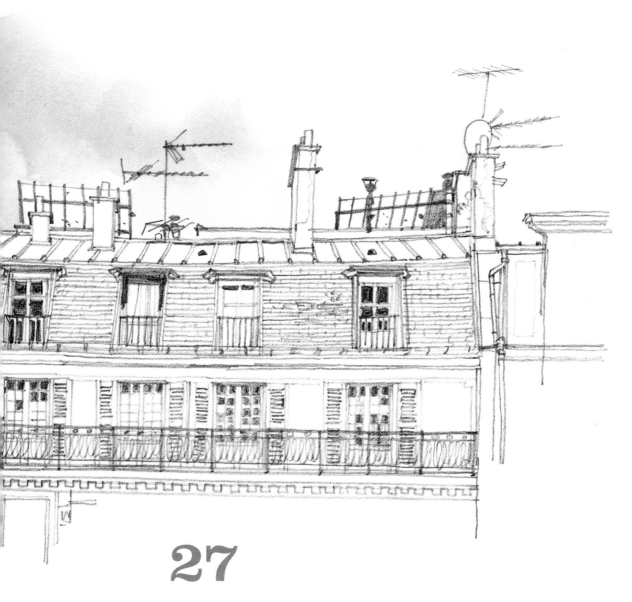

27

Chez Matisse

Matisse is asleep, leaning against the window. He's twenty-six, and elsewhere life is short – it's already wartime. The warmth of the morning touches the studio's large panes of glass. Matisse awakens, lifts his hand, listening, as if to music, to the tune his fingers trace in the air, playing with matter. Matisse opens his eyes, thinking of fields less bloody, purely chromatic. "The colour of light!" he will say, leaning like a tree towards the Pont Saint-Michel. At that time, he used to liken himself to a pear tree and Picasso to an apple tree. Matisse takes up his brushes, paints a nude, counts doves. Happiness moves from breast to beak, or feasts on a simple goldfish bowl. Still life, odd-looking clusters of shells, the Seine below, a sudden blue, and a bridge now endowed with feet the colour of fawn. Matisse looks at his hand, full of life. He applies ink to paper, then, ignoring the window frame, with large brushstrokes he invites Notre Dame to step up to his corner of the sky where, on the roof at Number 19, his chest against the window, he finally admits to feeling dizzy.

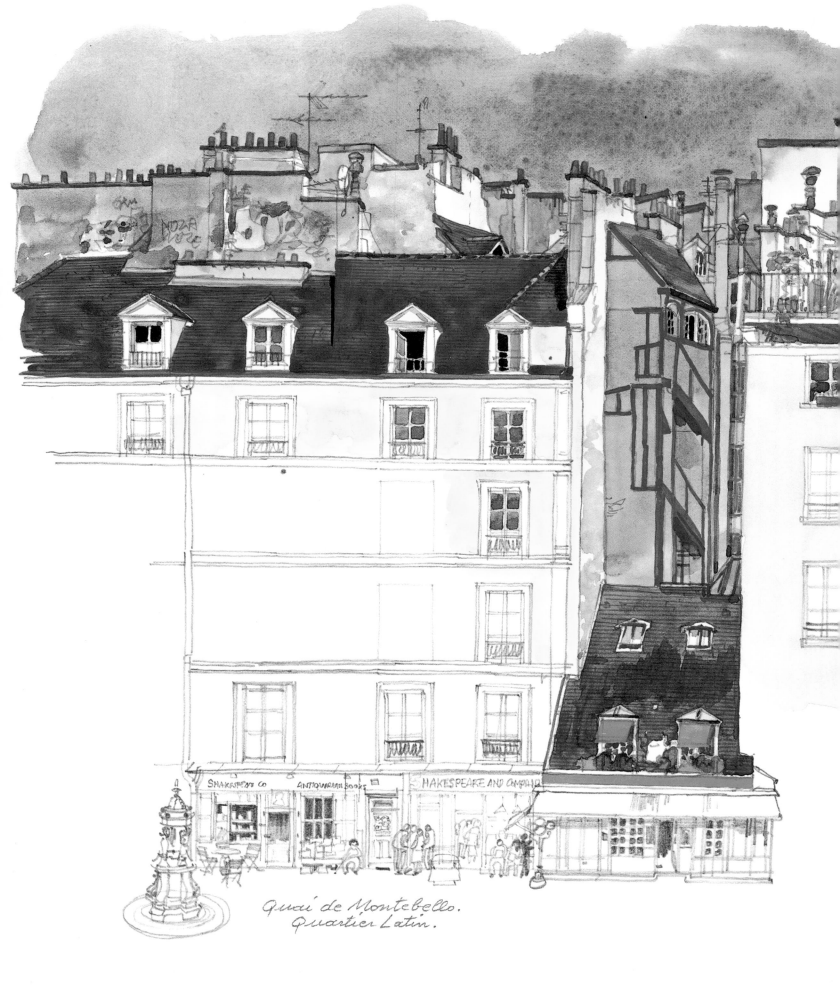

Quai de Montebello.
Quartier Latin.

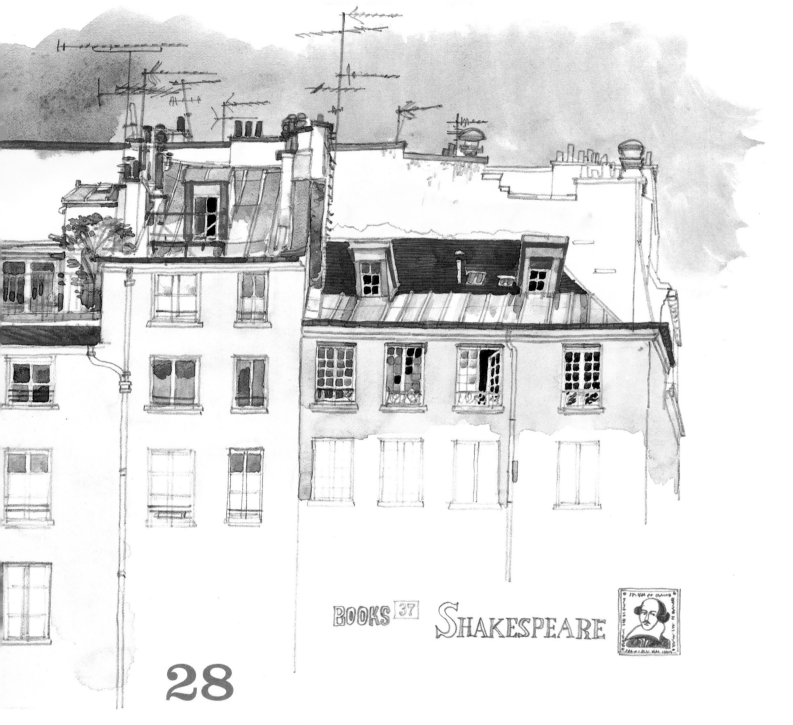

BOOKS 37 SHAKESPEARE

28

Shakespeare & Company, Paris

On a grey, drizzly morning, wedged between two taller buildings, the little house, weathered by time, breathes through its roof. From afar, it looks like a stage set, a cardboard decoration, put up and forgotten, the actors all gone, struck down perhaps as if in a Shakespearean tragedy. The house seems to consist of a staircase, with protruding windows, leading up towards a slightly shakey roof; it's masquerading as a tumbledown shack to hide the treasures within. The important thing, it seems, is to have pushed up towards a ray of light, to have sprouted like a plant and flowered through the roof, where the eye can linger and the afternoon sun can bring a friendly warmth.

29

Between snowflakes and iguanodons

Who is that wandering about on the roof of the Galeries de Paléontologie, between pigeons and iguanodons? A reckless scientist, a stealer of bones, a park keeper or just a lover of heights? Paris is under snow but that weighs little upon his dreams. Spring is hidden, glistening, but he keeps walking. Down below, umbrellas tell the story of Paris. Just one plop, and the flakes turn to a little spray of water. Sadness is in the streets, on wet coats already thawing, or in the gutters. But where is this unknown man, in search of a fall? The long stretch of white in front of him is like a gentle song to his eye. He seems to be one sky ahead of us, a finger dipped into the universe, as if tasting cream. Down below, in a gallery of the museum, among the whalebones, time stands still.

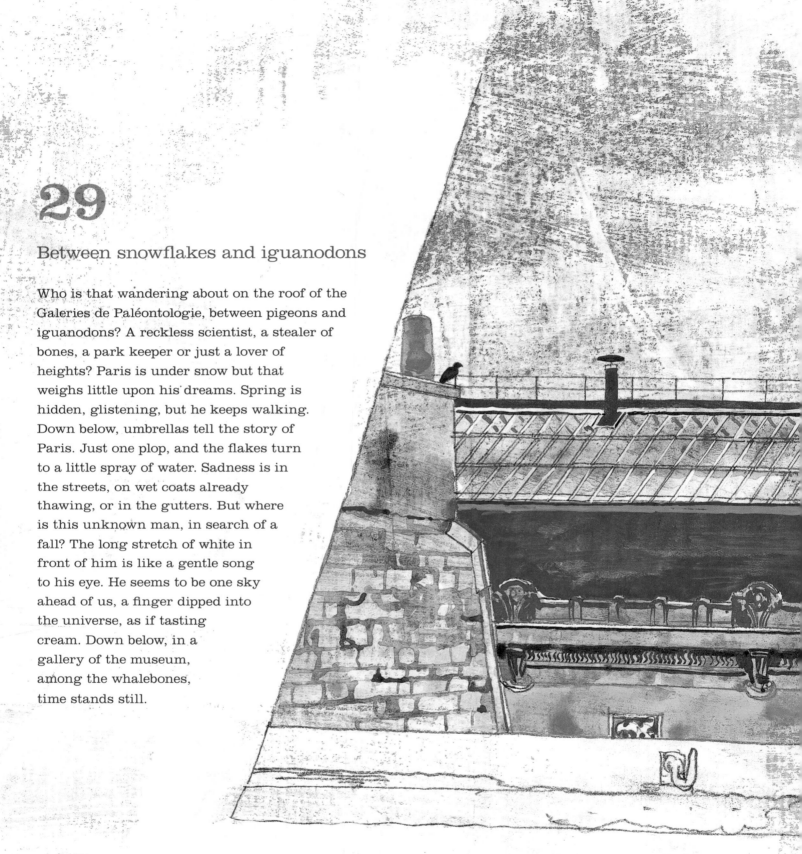

The Natural History Museum, Jardin des Plantes.

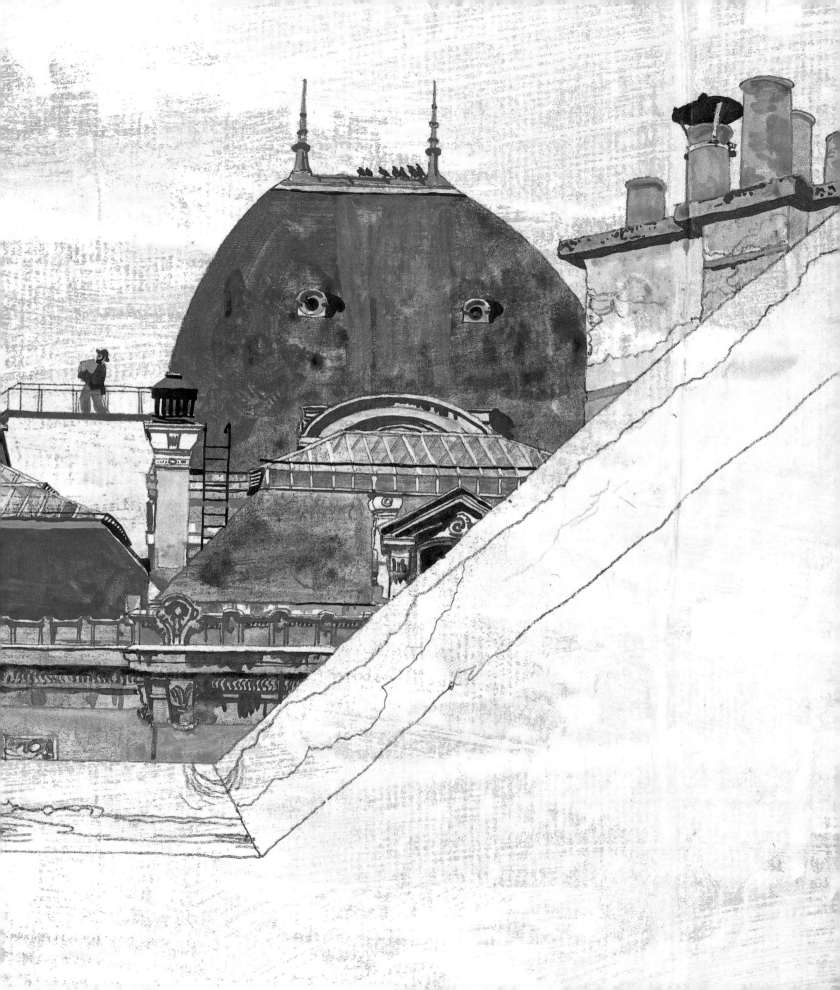

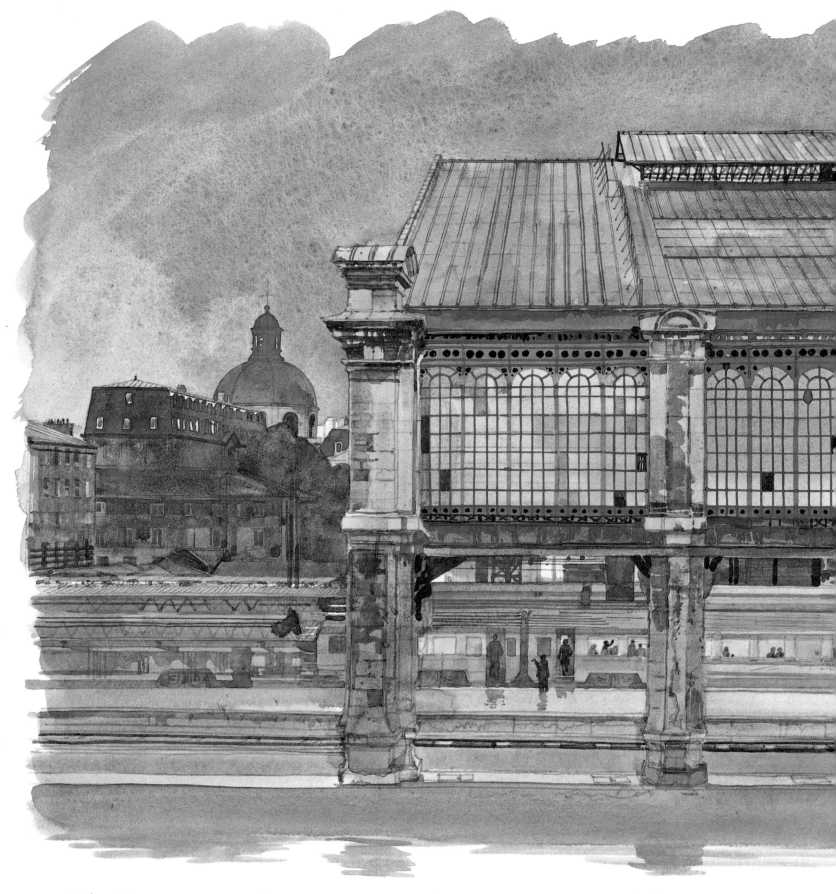

The Gare d'Austerlitz and the dome of the Hôpital de la Pitié-Salpêtrière.
13th arrondissement.

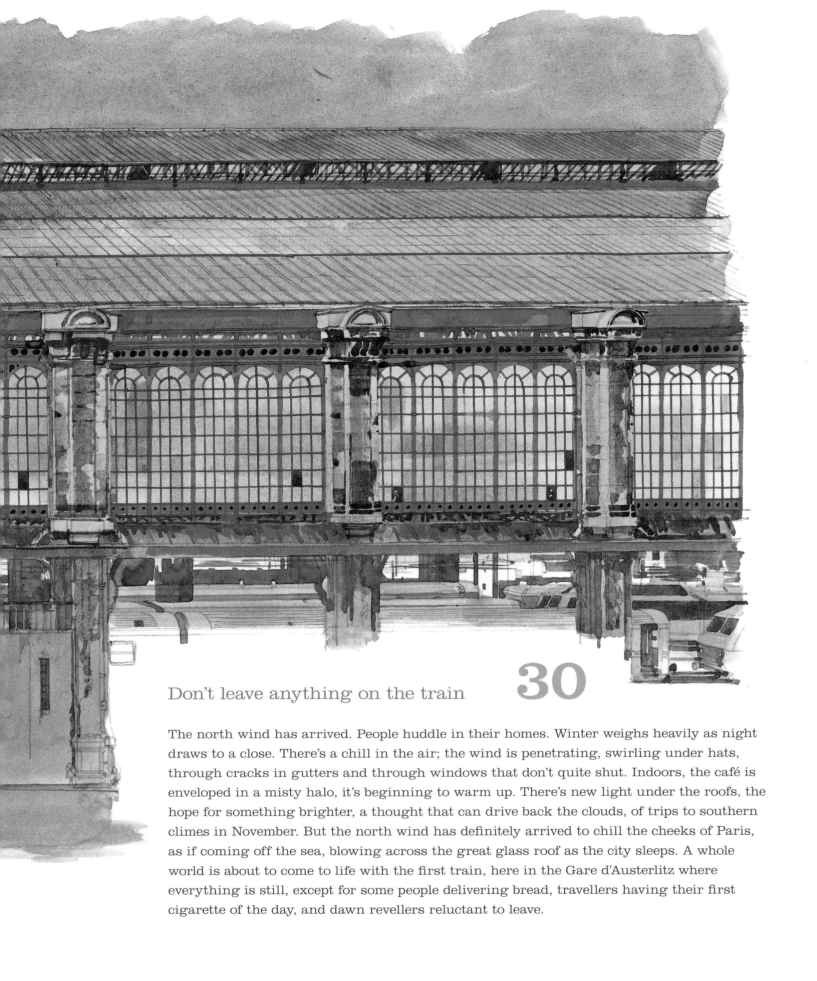

Don't leave anything on the train **30**

The north wind has arrived. People huddle in their homes. Winter weighs heavily as night draws to a close. There's a chill in the air; the wind is penetrating, swirling under hats, through cracks in gutters and through windows that don't quite shut. Indoors, the café is enveloped in a misty halo, it's beginning to warm up. There's new light under the roofs, the hope for something brighter, a thought that can drive back the clouds, of trips to southern climes in November. But the north wind has definitely arrived to chill the cheeks of Paris, as if coming off the sea, blowing across the great glass roof as the city sleeps. A whole world is about to come to life with the first train, here in the Gare d'Austerlitz where everything is still, except for some people delivering bread, travellers having their first cigarette of the day, and dawn revellers reluctant to leave.

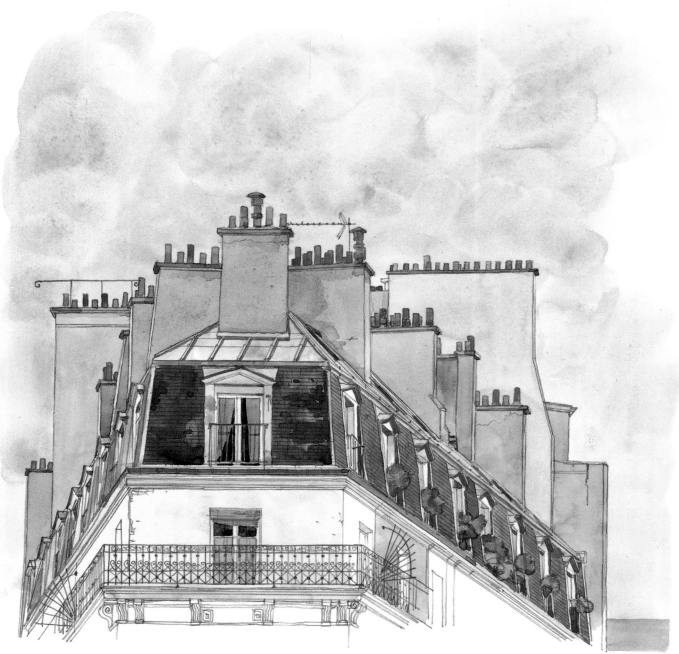

Avenue Claude-Vellefaux.
10th arrondissement.

31 All aboard

You thread words onto the string of thoughts, a few glass beads to peer into the distance and see how Paris dances to the rhythm of the rooftops. A cloudscape or two pass by. Every moment is a step. From above, the crowd seems far away, a distant refrain that is heard but barely registered by the eye focused on the spirit of the heavens.

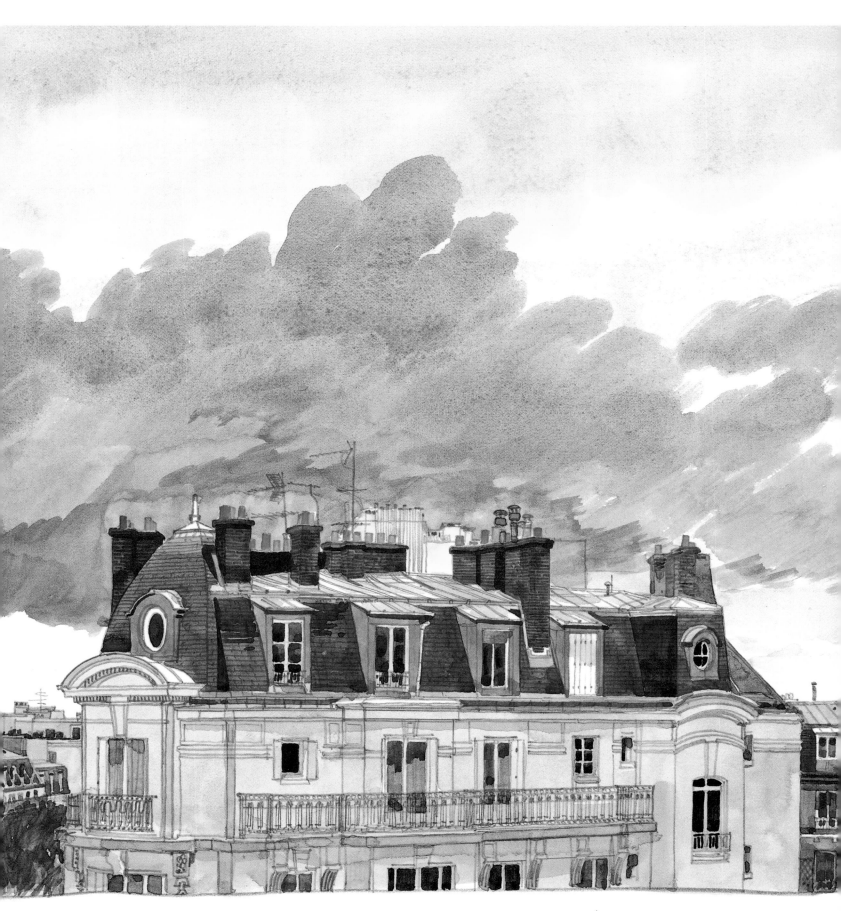

Avenue du Général-Leclerc. Alésia.

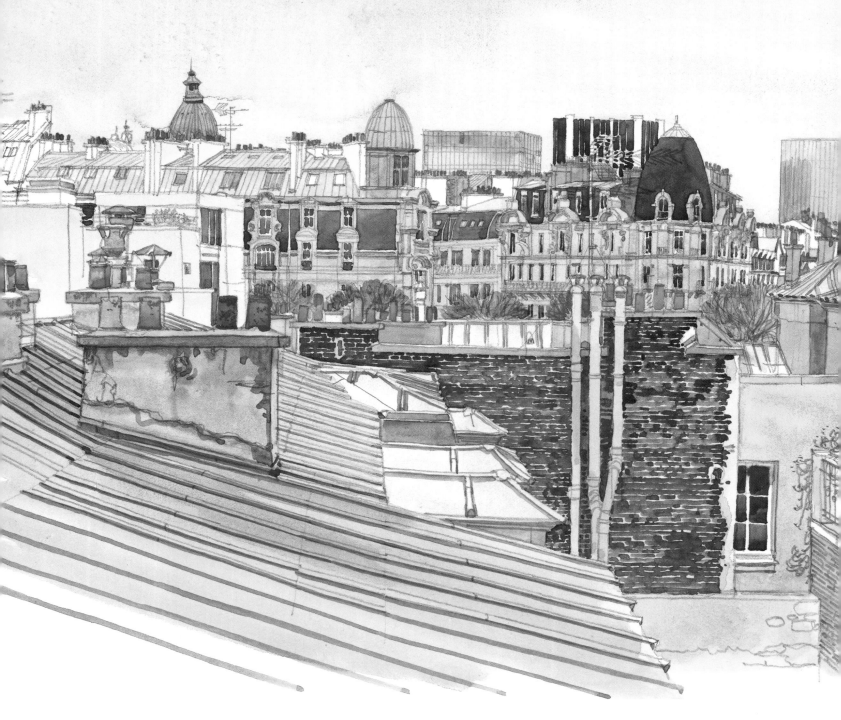

Rue de Charenton.
12th arrondissement.

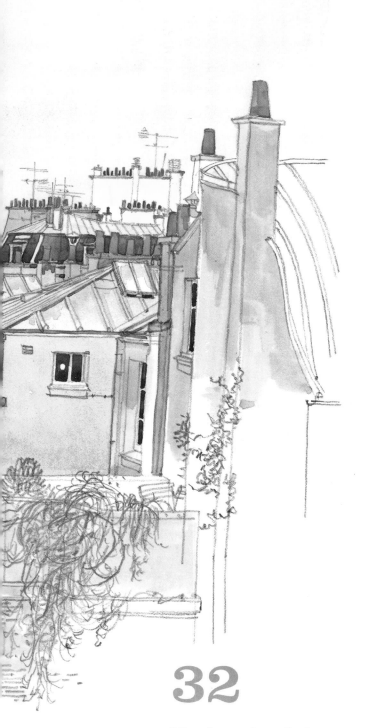

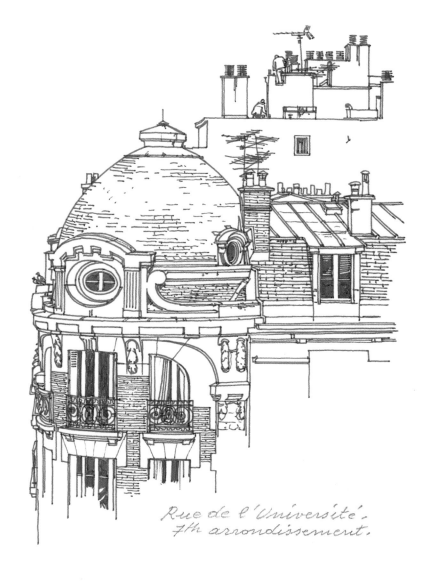

Rue de l'Université.
7th arrondissement.

32

The beauty of chaos

In Paris, the roof is the city's least Cartesian aspect. A welter of materials, a desire to leave one's mark under the open sky: spike, cupola, dome, vertical line, a shape like an ammunition shell, a glass roof singing in the rain – we are in a tangled, overlapping unknown. Painters have felt the exuberance of a hidden Orient up there, or a sense of chaos, but nothing is more Parisian than this determination to make a world in one's own image, of choosing to be one's own self, and of holding on to that until the next world.

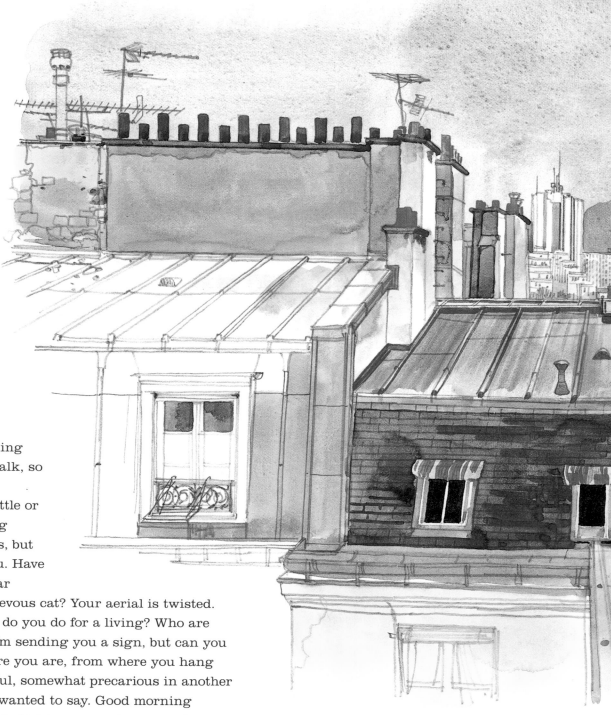

33

Dear neighbour

Hey neighbour, I'm looking at you for a chat. Eyes talk, so do arms crossing and uncrossing, moving a little or slightly askance, talking casually. Not prosperous, but close to the sky, like you. Have you seen the drizzle, dear neighbour? That mischievous cat? Your aerial is twisted. Does that matter? What do you do for a living? Who are you, under your roof? I'm sending you a sign, but can you see this wink from where you are, from where you hang your hat? Life is beautiful, somewhat precarious in another language, that's what I wanted to say. Good morning and good evening, see you tomorrow, maybe never, dear neighbour from the other shore, from the other skylight. It's going to rain, but it's Sunday after all, time to let your eyes wander, far from words that weigh down conversations.

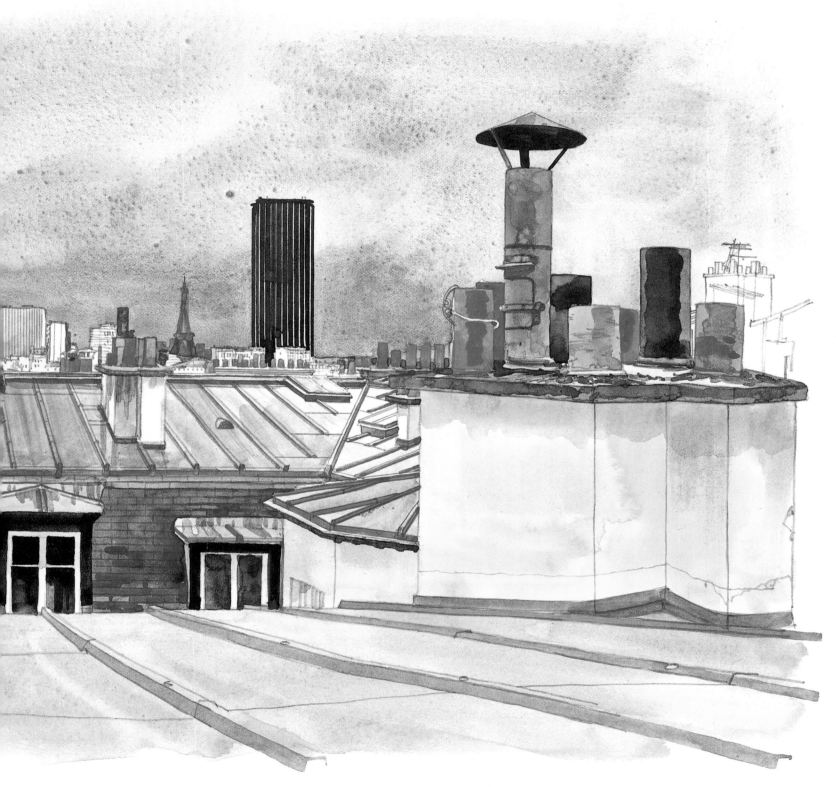

Rue Victor - Considérant.
Denfert - Rochereau.

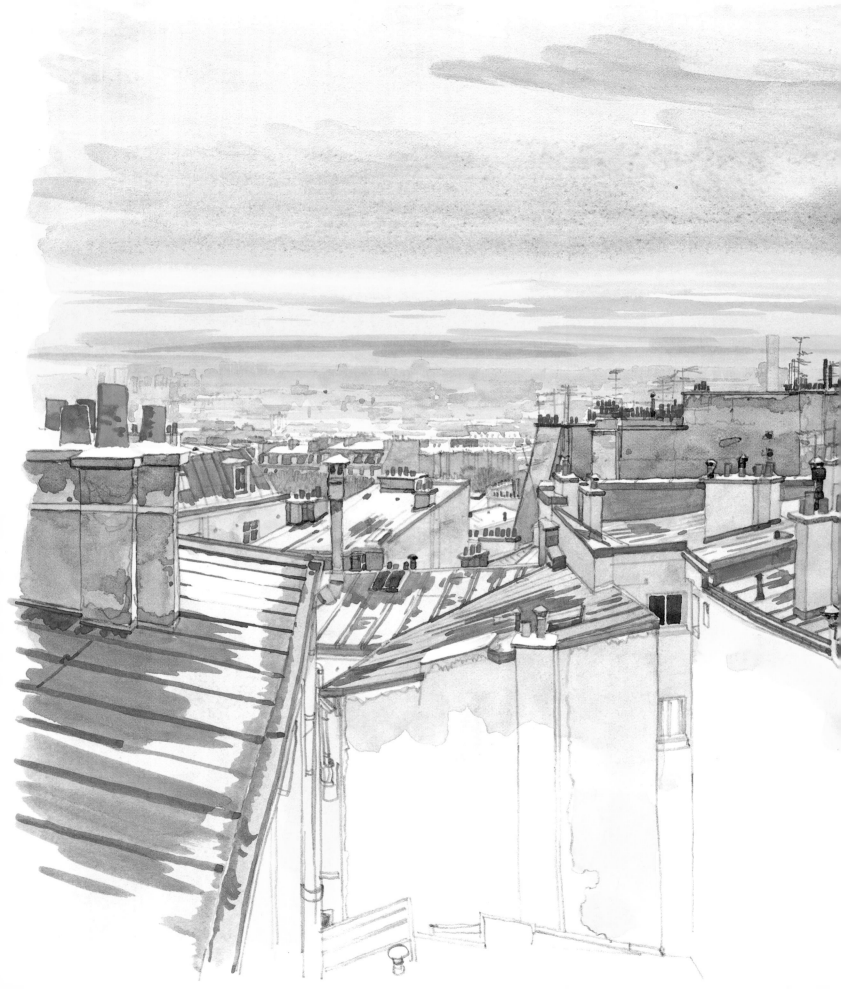

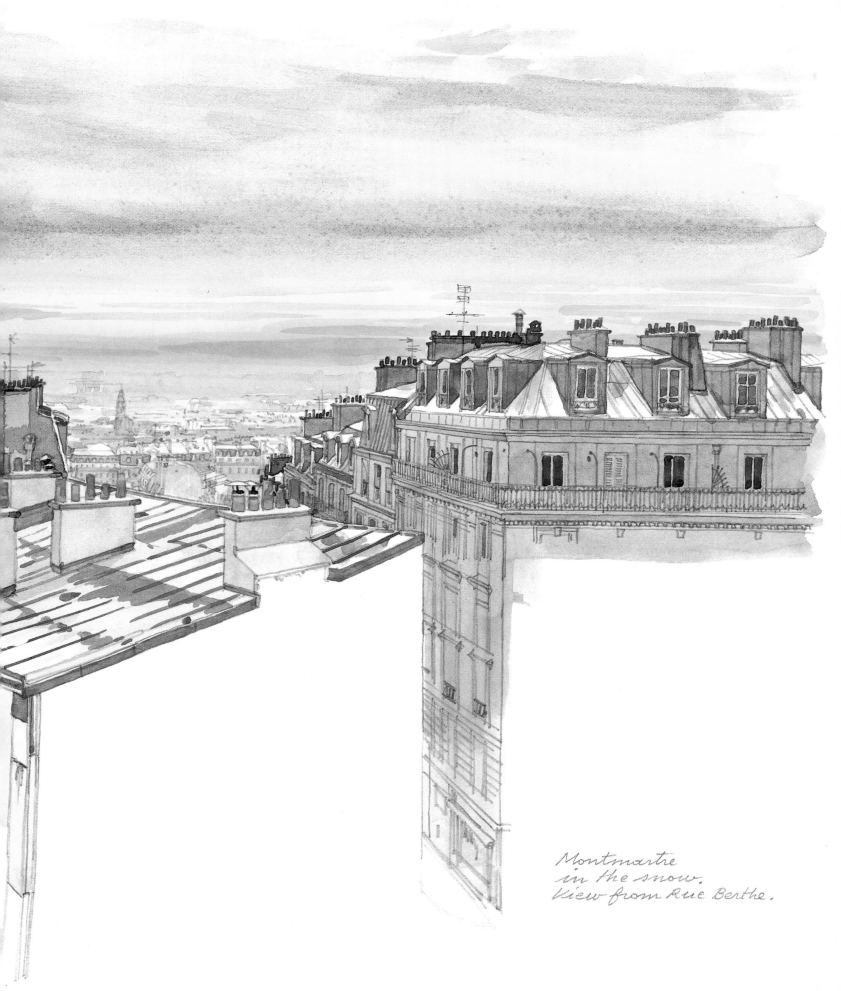

Montmartre
in the snow.
View from Rue Berthe.

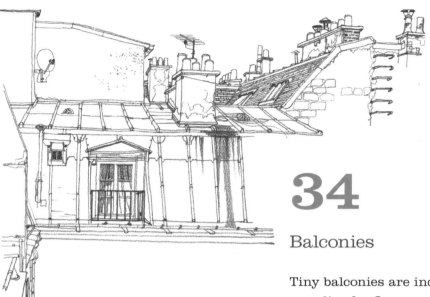

34

Balconies

Tiny balconies are indifferent to the stars. A paradise for flowerpots and pigeons, their narrowness leaves little space for men. Dangerous to lean over, but encircled with iron, often geometric or forming decorative motifs, they sit up there in state with a kind of false humility. They reflect the sun in all kinds of ways, an echo of times past under slanting beams of light. They rise in tiers to the rhythm of the façades, accompanying and punctuating windows that interlock with each other, repeating themselves like portholes on an ocean liner. These little balconies don't gape open-mouthed at the sky, a vastness that to them seems too featureless. They are tiny spaces, places to accommodate our dreams.

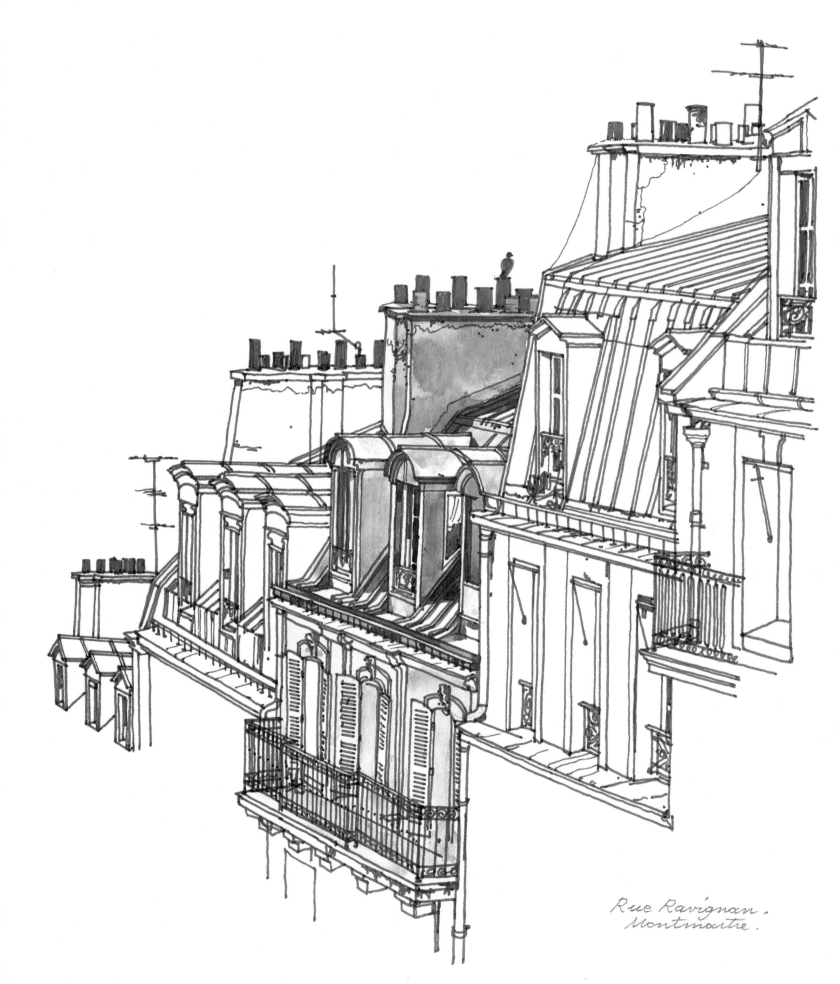

Rue Ravignan.
Montmartre.

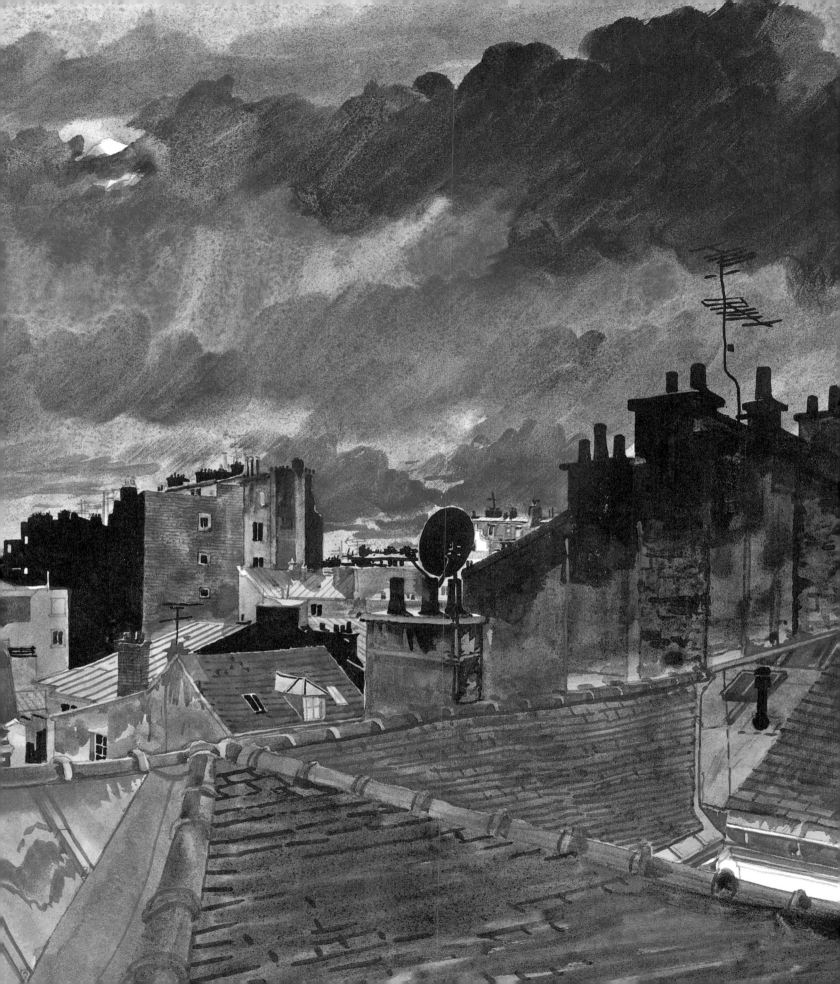

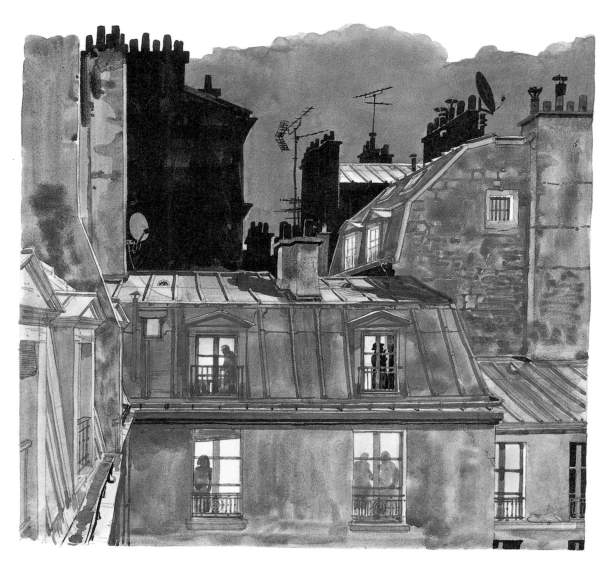

Rue de
Ménilmontant.
Belleville.

35

Night time in Ménilmontant

Night grows pale at the window. Ménilmontant grows quiet. Several lights seem to be dozing off, but still keep watch, beacons where shadows slip by, without need of the moon. Behind the glimmering lights, everyone has someone, an embrace, the weather forecast, a soap opera. Sometimes a curtain bangs like a door, a cat sharpens its claws, the clock ticks on, a small world unfolds along the thread of time while the sky takes on bolder, electric blues, demanding a more direct look.

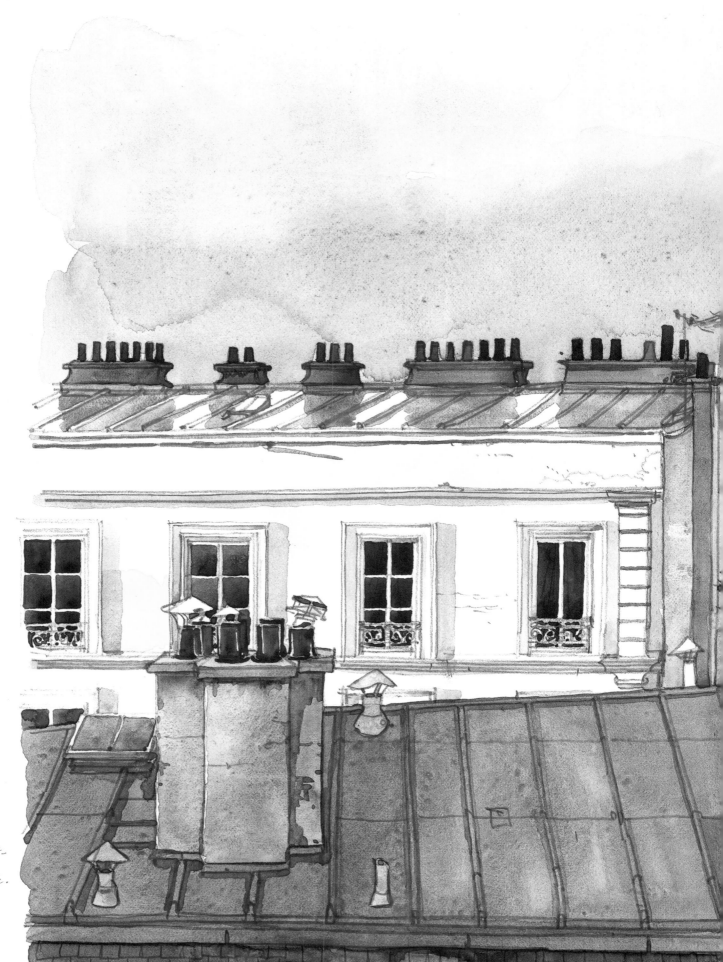

Rue Saint-
Éleuthère.
Montmartre.

36

The first aerial photograph

Paris fills your eyes. No need to move. The blue sky becomes a song. The roofs are perched like cats high up. The sky is a passer-by. Without a word, without a movement, Paris gives of itself. In Saint-Eleuthère, in January, beauty works its way into the scene. A landscape of attic windows and chimneys opens up where each is special, without actually flying. It was on a day long ago, not far from the squares of Montmartre, from the Cimetière du Calvaire and the Wallace Fountain, that from a tethered balloon a dreamer by the name of Nadar took the world's first aerial photograph, rising up in the air to allow Paris really to fill his eyes.

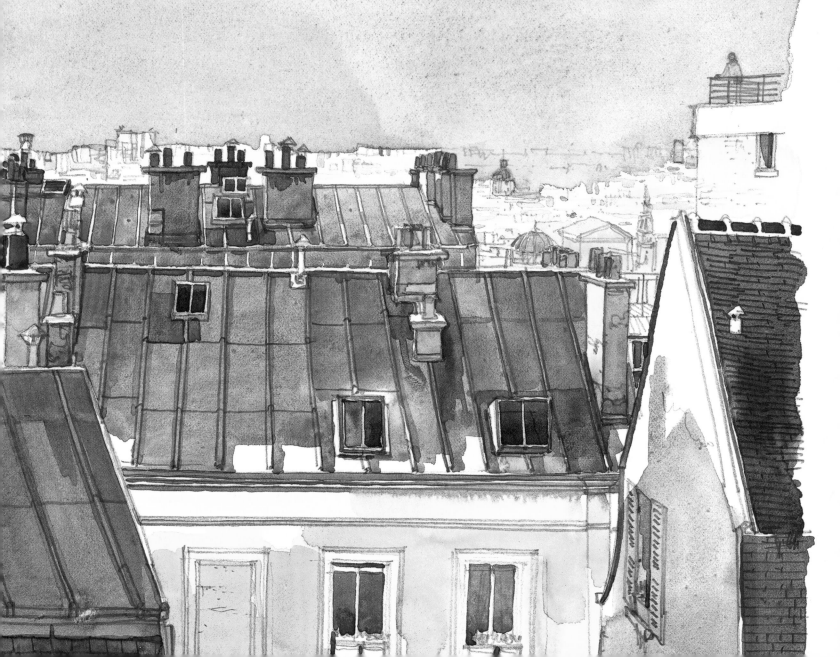

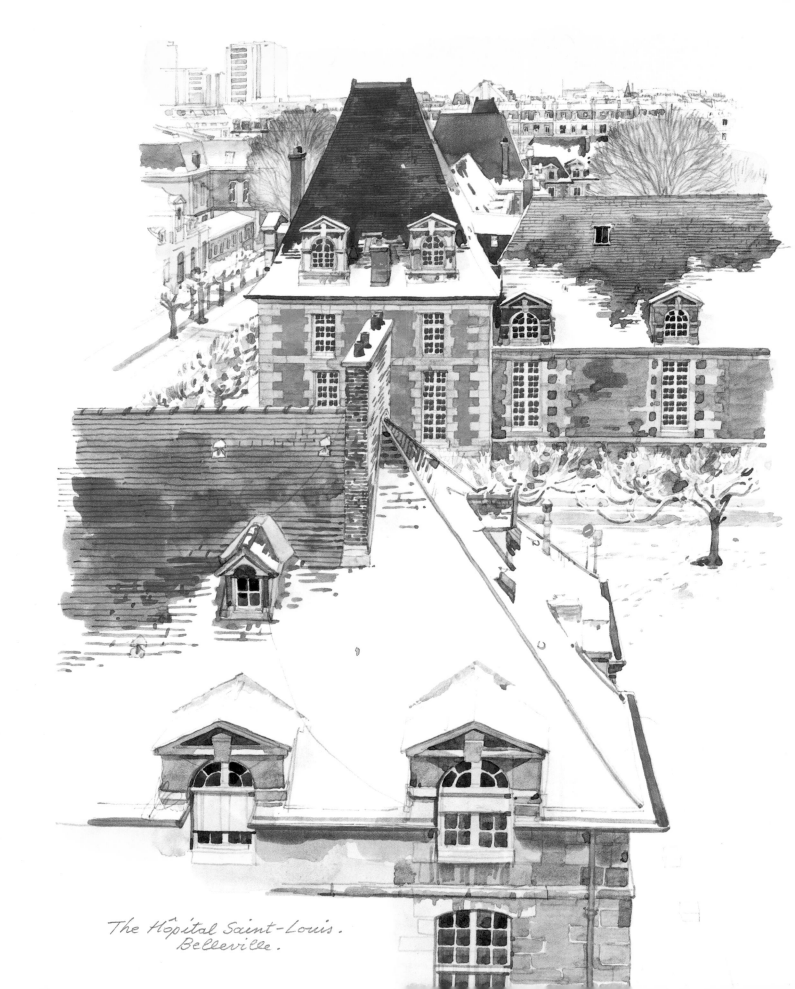

The Hôpital Saint-Louis.
Belleville.

37

The patience of snow

Here we must speak of the patience of snow. Of its jazz-like quality as it falls, improvising, of its indistinct voice as it lingers, hesitating before settling. But also of its wisdom, that can be seen by anyone who slows down. It gently covers; it does not decorate. It follows the waves of corrugated iron sheets. Today, this talent for contemplation is shown up in the grounds of the Hôpital Saint-Louis, reminding us of fields of old, of that century of plague, of nursing-home wards with ceilings high as a church, of that place of healing, of contagion too, where, to escape fate, eyes lifted to the glass roof, you had to recite your "Quis contra Deum, sine Deus ipse". Nowadays, the snow is left to its own thoughts, untouched by angels' feet. Once upon a time, nurses in white used to come and collect it up. The architects had made provision for ventilation and lighting, but not for drinking water; snow had to be taken from the roofs, frozen or not, for the washerwomen and the laundry. How good it still is to contemplate the patience of the snow. It has always been there to allow men, thus calmed, to look a little more deeply into their hearts.

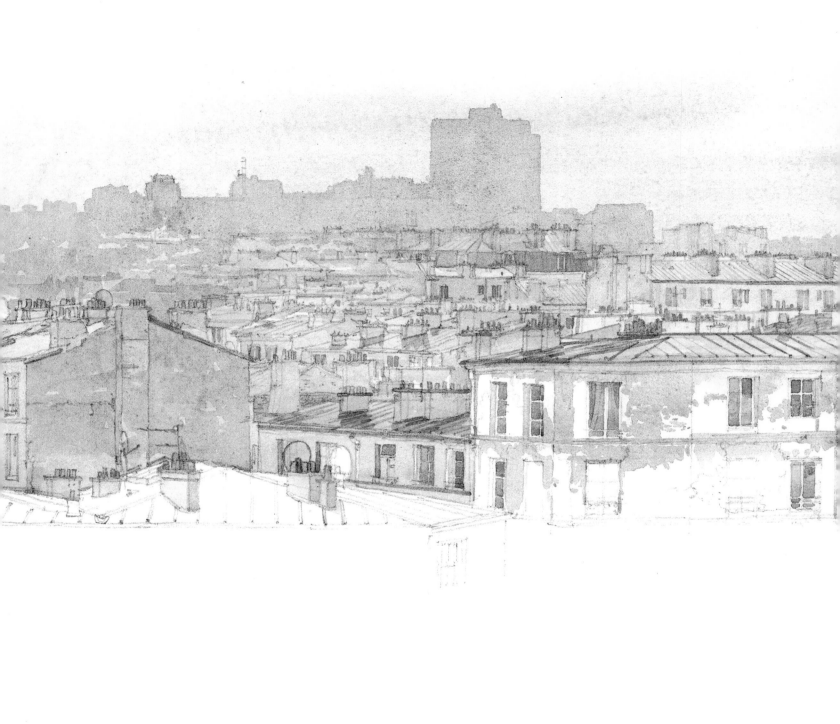

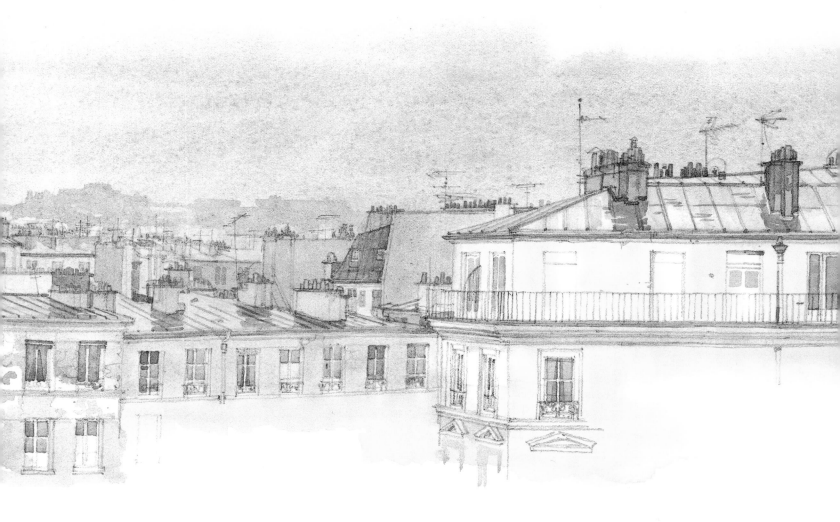

Quartier Sainte-Marthe. Belleville.

38

A misty dream

Roofs are not made for angels. Sometimes you discover your most earthly desires there. "If only we had a roof all of our own," say two lovers in passing. Imagine such a roof, there before any of the others existed, floating like some beauty seated in mid-air, with the promise that everything beneath would materialise even if a few low clouds or a mist over Belleville had to be dispelled first. Making your own roof just as you would make a nest, what a wonderful idea! To breathe with the bird that deigns to fly down. To forego all grandeur in order to focus on the most accessible cloud, the one that forms as a pair. To be free to move on, together with the other. To marry the skies and earthly places, sun and fog. To be roof or poem.

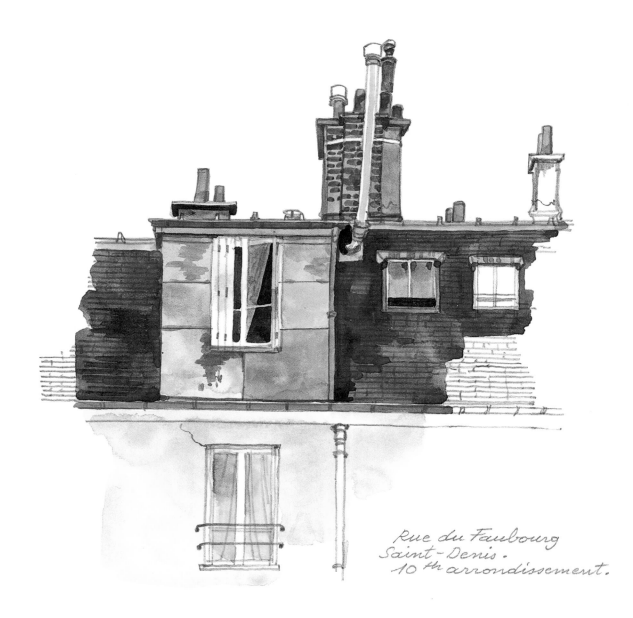

*Rue du Faubourg
Saint-Denis.
10th arrondissement.*

39

The blight side of Paris

There are some holes in the city, patches of rust above eye level, can you see them? To avoid upsetting the more elegant districts with its noxious fumes, industrial Paris lies to the east and north, warehouses like chessboards with uniform black squares, the Paris that is an affront to the city's leaded roofs, with violent transitions from one material to another. And there, other memories come flooding back, thoughts long-forgotten: images of caps and overalls, too-bulky sweaters and blunt talk. We tell ourselves that the roofs also bear the traces of hard work, of thoughts trying to escape from places too hot or too cold. There's history here, draining away, almost invisibly, through the rusty holes.

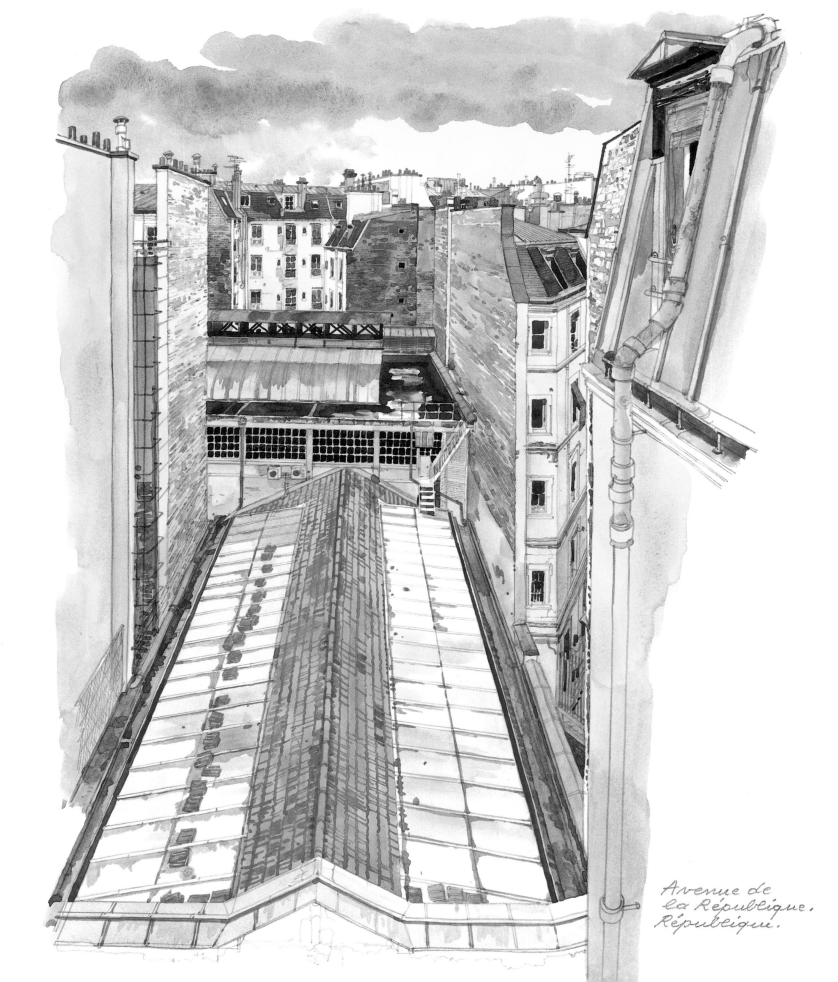

Avenue de
la République.
République.

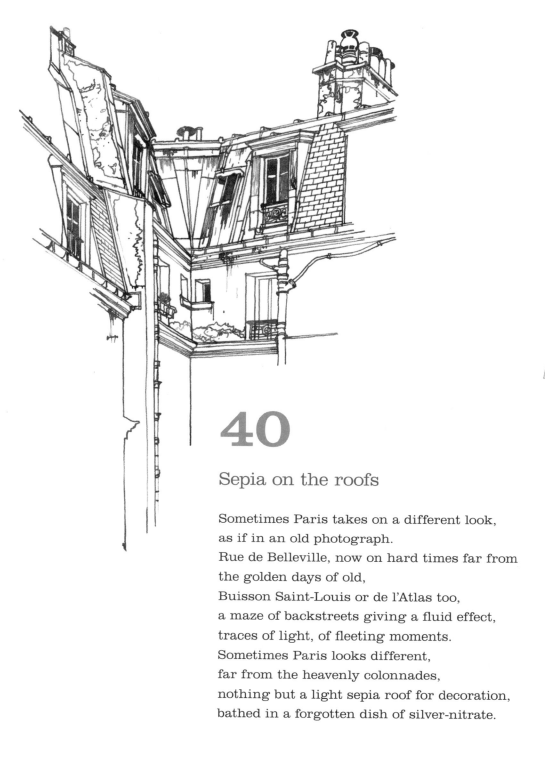

40

Sepia on the roofs

Sometimes Paris takes on a different look,
as if in an old photograph.
Rue de Belleville, now on hard times far from
the golden days of old,
Buisson Saint-Louis or de l'Atlas too,
a maze of backstreets giving a fluid effect,
traces of light, of fleeting moments.
Sometimes Paris looks different,
far from the heavenly colonnades,
nothing but a light sepia roof for decoration,
bathed in a forgotten dish of silver-nitrate.

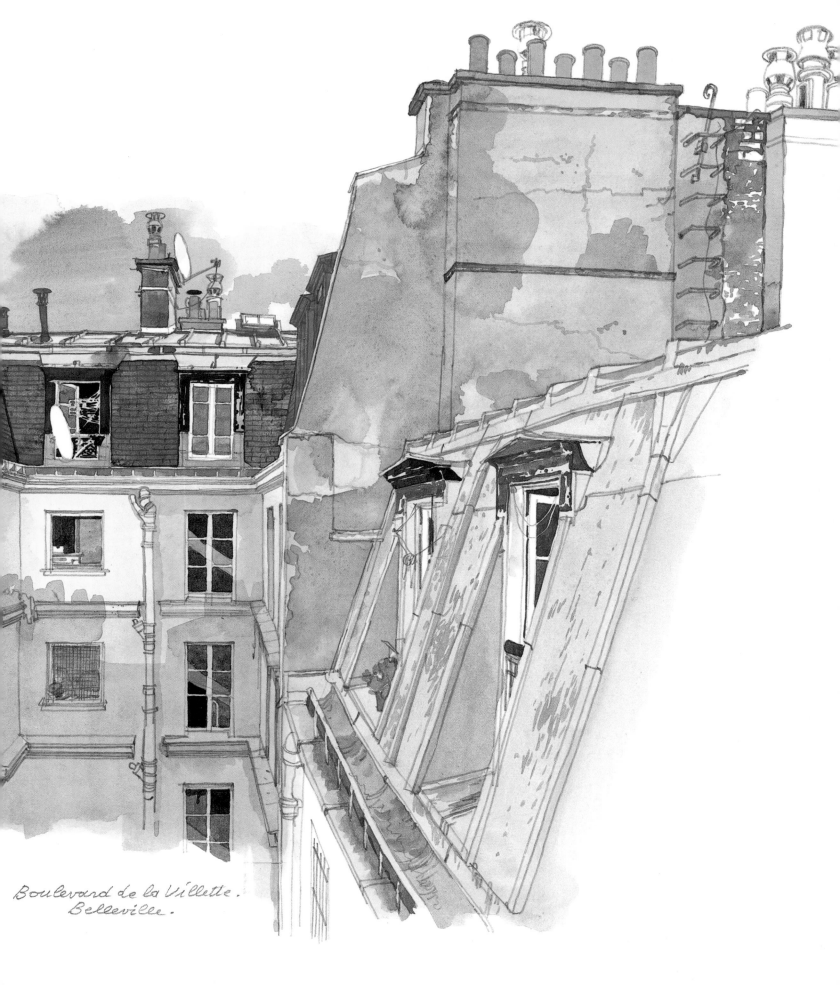

Boulevard de la Villette.
Belleville.

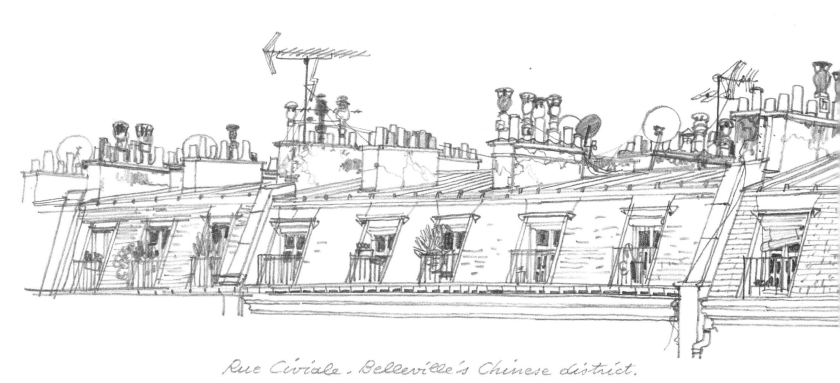

Rue Civiale - Belleville's Chinese district.

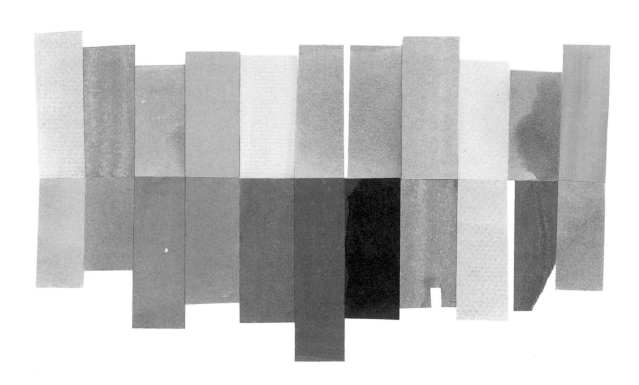

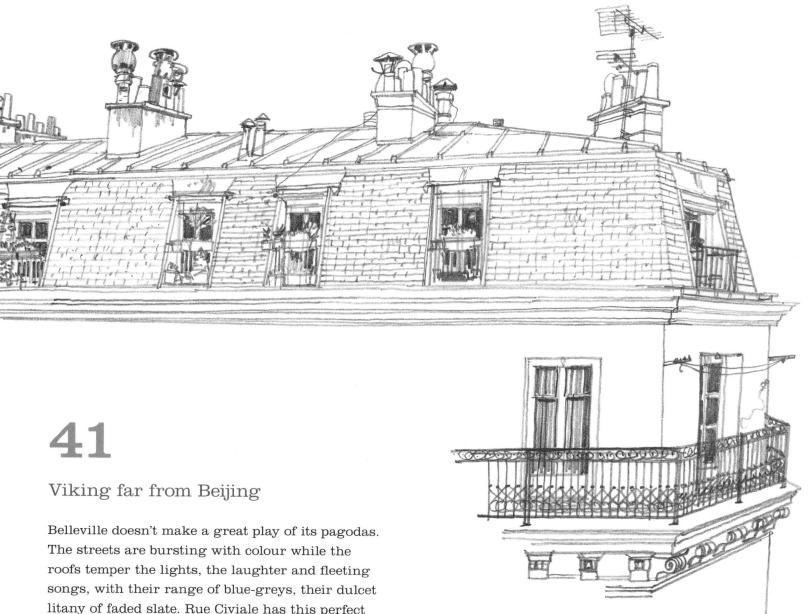

41

Viking far from Beijing

Belleville doesn't make a great play of its pagodas. The streets are bursting with colour while the roofs temper the lights, the laughter and fleeting songs, with their range of blue-greys, their dulcet litany of faded slate. Rue Civiale has this perfect upturned ark, with flowering balconies, a ship apparently silent, neither junk, nor felucca, nor sampan. Almost Scandinavian. Occasionally, a piece of washing, moving in the breeze, looks for its haiku. The sky all around waits for a kite that never comes. We dream of watching it float away, bright and eye-catching, and wrapping itself around the Eiffel Tower that, at night, seems to turn slowly into a giant neon tube.

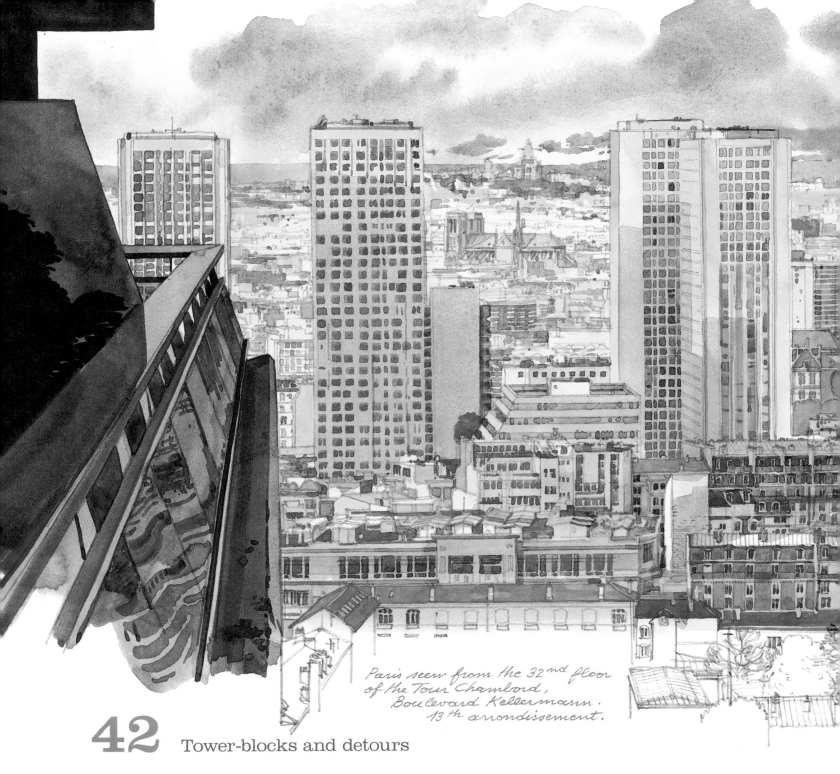

Paris seen from the 32nd floor of the Tour Chambord, Boulevard Kellermann, 13th arrondissement.

42 Tower-blocks and detours

There are some roofs that fill us with dreams. There are others that have let themselves go.
You can fall a long way from not very high. You can also aspire to a bit of sky at your
window, to enjoy the sun, to stretch out carelessly, even at the risk of falling, just for the
pleasure of being by yourself for a moment. As we come upon the tower-blocks of the 13th
arrondissement, we can see the great wide world beyond, and this book draws to a close.

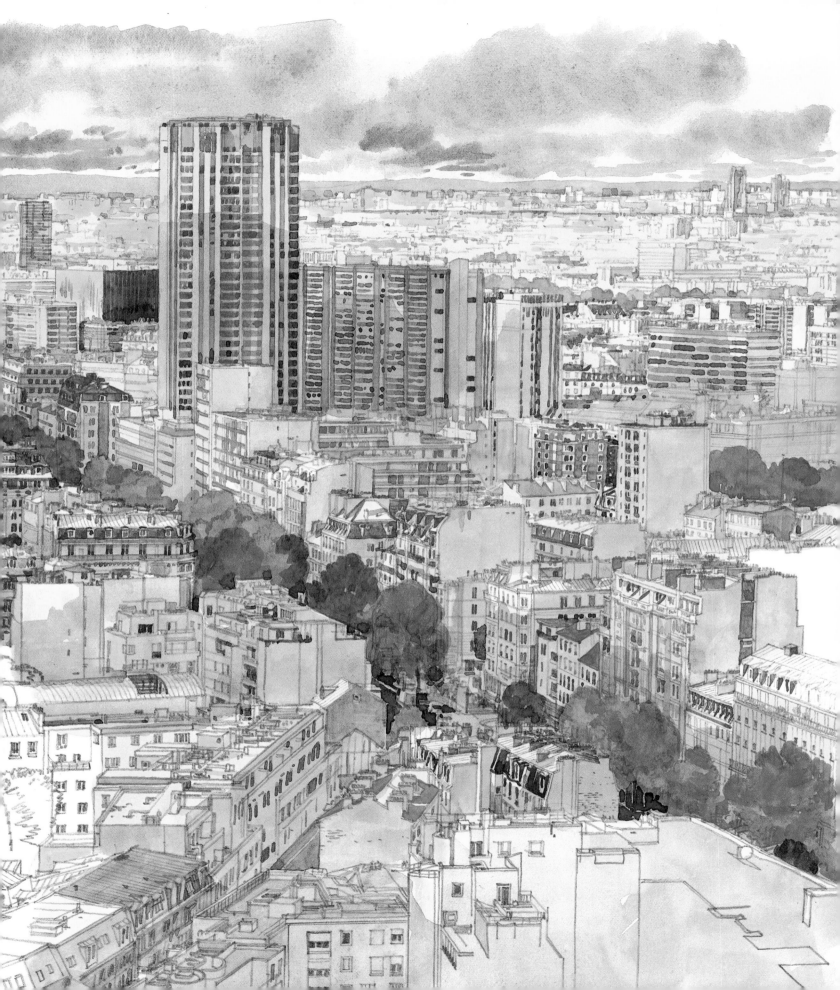

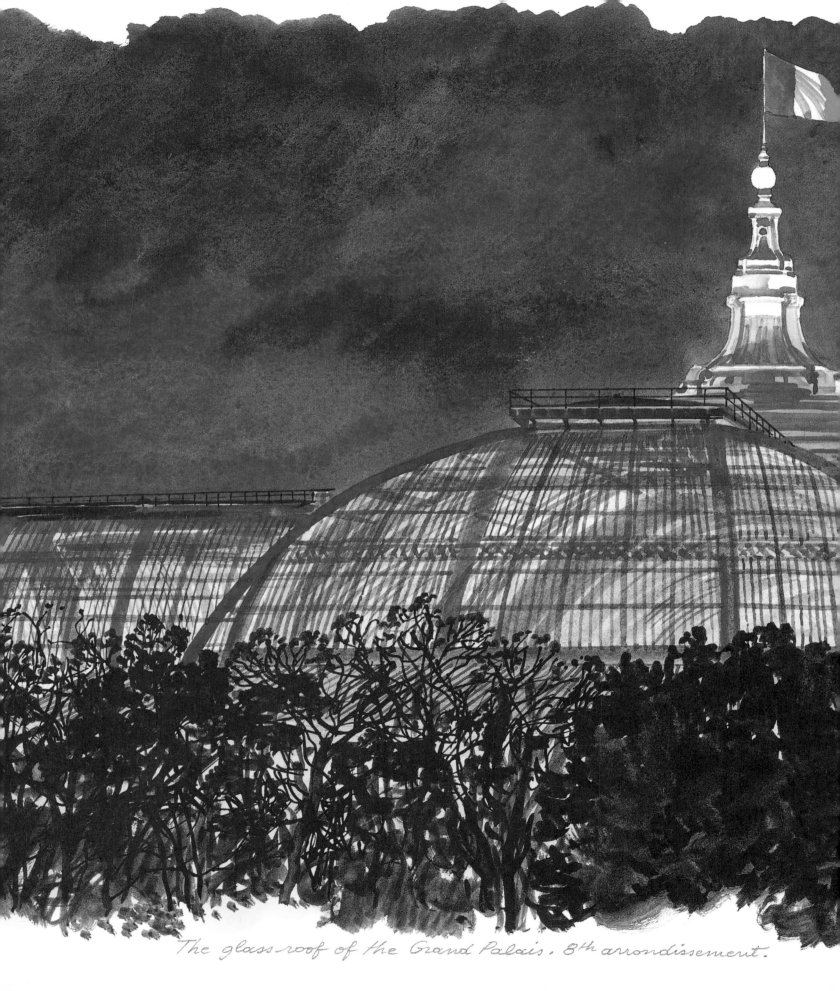

The glass-roof of the Grand Palais. 8th arrondissement.

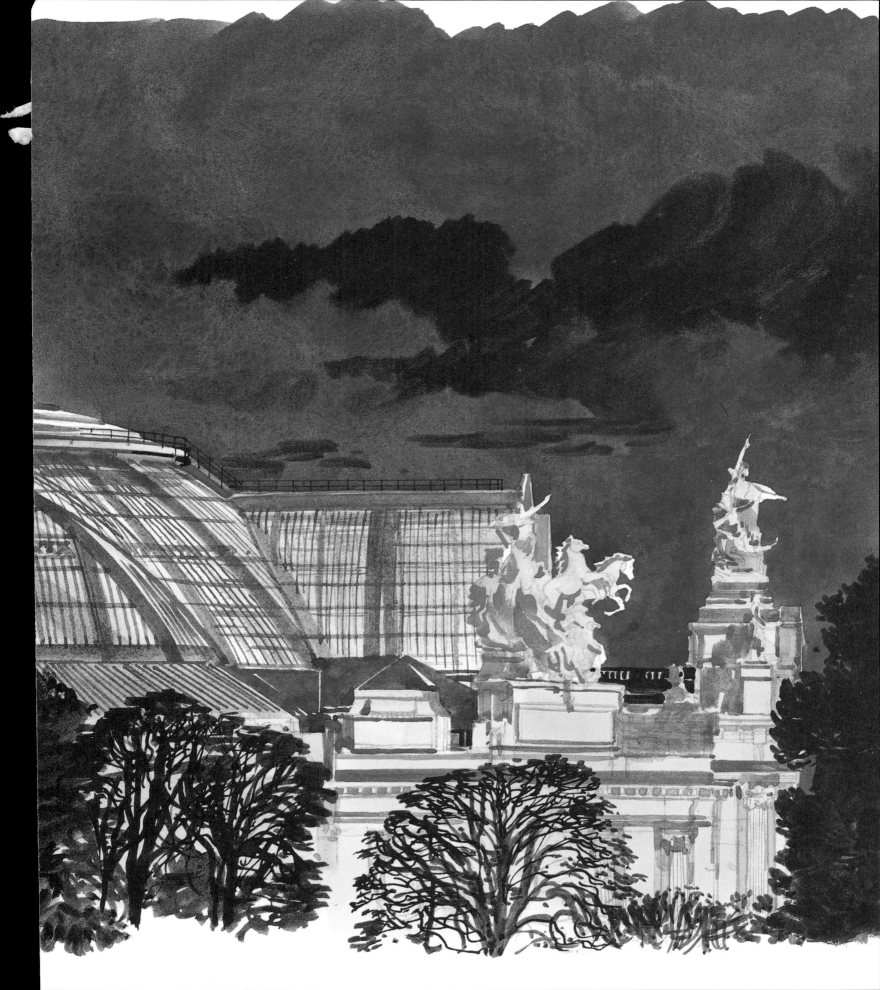

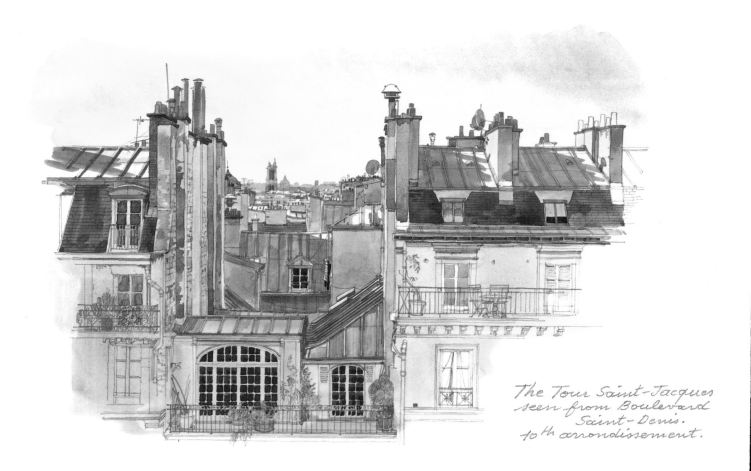

The Tour Saint-Jacques
seen from Boulevard
Saint-Denis.
10th arrondissement.

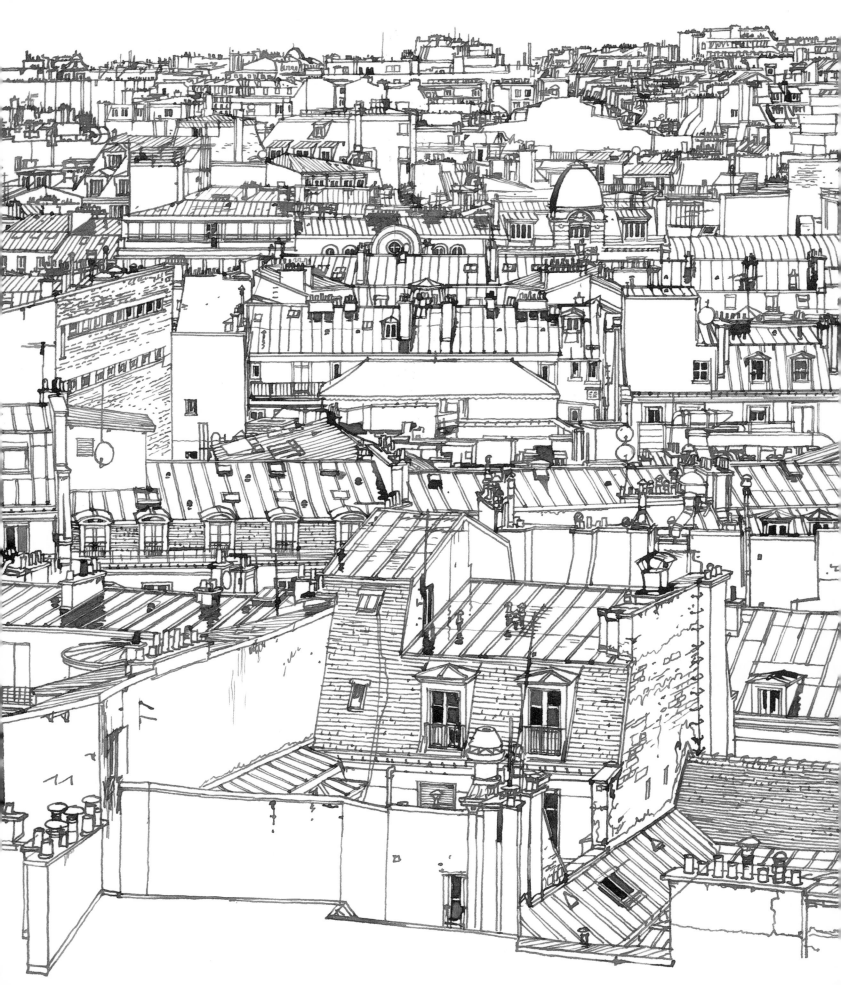